Items should be returned on or before the last date
shown below. Items not already requested by other
borrowers may be renewed in person, in writing or by
telephone. To renew, please quote the number on the
barcode label. To renew online a PIN is required.
This can be requested at your local library.
Renew online @ **www.dublincitypubliclibraries.ie**
Fines charged for overdue items will include postage
incurred in recovery. Damage to or loss of items will
be charged to the borrower.

Leabharlanna Poiblí Chathair Bhaile Átha Cliath
Dublin City Public Libraries

Date Due	Date Due	Date Due
7 MAR 2019		

Willie Doherty

DISTURBANCE

D1339041

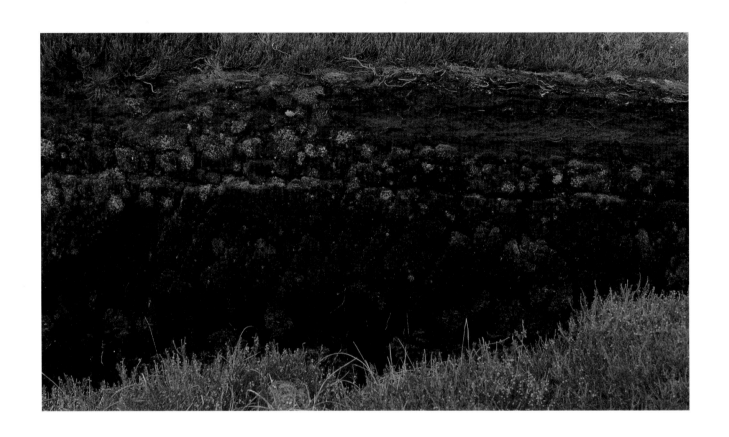

Willie Doherty

DISTURBANCE

Dublin City Gallery The Hugh Lane

DISTURBANCE

Willie Doherty is renowned for his video installations and photographs. DISTURBANCE at Dublin City Gallery The Hugh Lane surveys the artist's works from the early 1980s to the present day, including his most recent video, *Ancient Ground*, shot earlier this year on the peat bogs of County Donegal.

Ancient Ground focuses upon barely visible traces of human trauma within a rural terrain. Evidence of undefined violence is captured with forensic attention to detail, implying that whatever unspoken occurrences took place in the past will not disappear and cannot be forgotten. The artist's concerns with territory, surveillance and the part that land plays in cultural hegemony can be traced back to his photographs from the 1980s of his native Derry and its environs. Exploring an understanding of place through terrain, these iconic works, overlain with text, play out the dichotomies of the familiar appropriated by conflicting ideologies at war.

Doherty's work is rooted in the politics and topography of his native Derry, the walls of Derry and the River Foyle with its east bank, its west bank and the proximity of its border with the Republic of Ireland, which is, as he says, 'a perfect theatre of war'. His practice, however, transcends the specificities of any particular context, as this exhibition reveals. The current work shifts between the urban and the rural. What the terrain has witnessed is patiently tracked down and the artist's discoveries of the scars of human activity on the land are yielded up and captured on camera. Doherty unflinchingly confronts the underbelly of society, making what is concealed more visible. The insistent repetition of text, and the constraints of imagery within that circularity of language, emphasise the sense of entrapment; who is the perpetrator, who is the victim? Calling himself an old-fashioned landscape artist, Willie Doherty holds a unique position in contemporary art. His engagement with the land is very

particular – shifting ground upending the surety of position. His surveillance of territory looks for evidence of association with social and political concerns and is carried out by walking it or watching it through the windscreen of a car or bus window. What he uncovers appears in a series of images which fully acknowledge the ambiguities, complexities and paradoxes that brought them into being.

We are delighted to present Willie Doherty's first exhibition at Dublin City Gallery The Hugh Lane in collaboration with Dublin Contemporary. My sincere thanks to Willie for his support and for generously agreeing to be interviewed and to Colin Graham for his insightful text on the artist and his work. My thanks also to the lenders, without whose support DISTURBANCE could not have taken place; to Michael Dempsey and Logan Sisley who coordinated the exhibition and to Padraic Moore who assisted with its realisation. As always with our exhibitions, the support of all the staff is greatly appreciated and central to the success of the programme.

Barbara Dawson
Director

Inscription | Trace

Back and forth the gaze beating
against the unseeable and unmakable.
Truce for a space and the marks of
what is to be and be in the face of.
Those deep marks show.[1]

There may be something in the water. It could be the faint outline of a man-made object, or even of something that was once worn by a man. But the tones of the bog water have soaked into it, turned it rust-coloured. It may be evidence of something that has happened. It may be illusory. There may be a story.

Dead Pool II, in Willie Doherty's recent *Ancient Ground* series, is an image which is the epitome of his work, reduced to a clear simplicity. It has a sure sense of colour – that deep blue of bog water which has soaked up the sky and the parched brown and imminent surge of green in the grass and heather. It has an uncluttered vision of place, and stands as an image at eye-level, looking down, with the vision of someone who surveys, searches or accidentally comes across this moment and turns it into a remnant, evidence in a scene. Because it scrutinises, stops short and stares, within this image's clarity the natural landscape is charged with an ominous resonance, the sign

of human failure, the aftermath of a moment when the human is degraded and left as a trace of a previous existence. 'Those deep marks show', as Beckett wrote of Arikha, and in Doherty's work the mark, once an inscription, is now more often a trace, the sign of a sign, and all the more powerfully contemplative for its allusiveness.

Willie Doherty's art, starting with photography and then combining that work with video, is rooted in a dialectic which considers the material world, its politics, ideologies and physical substance on the one hand, and on the other the stories and possible existences which that world contains and constrains. Doherty's early photographic works from the 1980s dwell on the binaries of Northern Irish politics as they play out their deadly ironies over contested land. But in these early images there is an itch of recognition of a larger field of contestation, signalled by the land itself and by a natural order of which the human is part. So in *The Other Side*, 1988, the words on the image

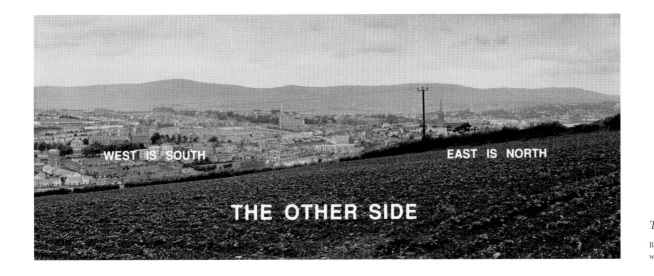

The Other Side 1988

Black and white photograph
with text, 61 × 152 cm

proclaim the suffocating contortions which cultural geography layers over physical geography in Northern Ireland – the twisted logic which can blankly assert that 'WEST IS SOUTH' and 'EAST IS NORTH'. The words imposed over the landscape take precedence in the image, and are pivoted around 'THE OTHER SIDE', the artist/author's comment on what marks the politics of this place. Such is the power of the way in which these words score the work that it is easy to miss the other dichotomy which holds this image together while splitting it. Not a land which is only either 'ours' and/or 'theirs', but a land which is rural and urban. It is an interspliced binary which Doherty makes use of throughout his work – the constructed against and in the natural, the human against and in the landscape, the manufactured and built intertwined with the organic. *The Other Side* may be visually overlain by words, but it is also cut across by the dark outline of a hedge bordering a field, marking the gap which divides ploughed land from houses. It is a double division of words and images which should alert us to the further meanings of 'the other side' – there is, in Doherty's work, not just the process of thinking about the politics of borders, or cultural histories, or cultural languages, but a deeper sense of the difficulties of visual and linguistic communication. As Doherty's work changes through the 1990s and into the current century, the white, inscribed words, with their assertive upper case,

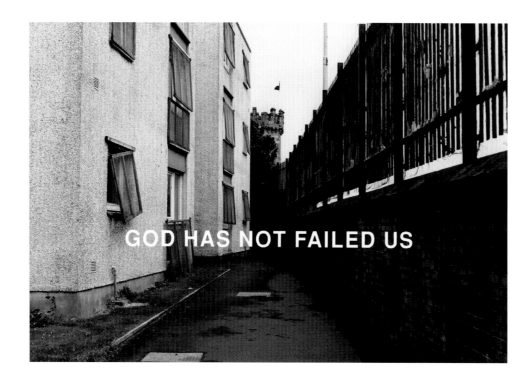

God Has Not Failed Us
(The Fountain, Derry) 1990

Black and white photograph with text,
122 × 182 cm

10

disappear from the image. The application of conceptual pressure on political definitions remains, their meanings challenged constantly by the consideration of the borders which give definitions to things, keeping them apart and holding them together. Doherty's work stays rooted in the cultural and political divisions which are signalled in the surface writing on *The Other Side* but, out of this origin, it delves into the metaphysics underlying this cultural stasis and taps the ennui which this politics generates. The disjunctive stories of his video work, which continually promise but do not deliver a linear narrative, and the hints at death and life which, sometimes literally, litter his images have their origins in the double-layering of his early work.

Such a recognition of the way in which Doherty's work comes to allow for the interplay of connected binaries and the excavation of layers of meaning, gives us a backward look at early work from Derry such as *God Has Not Failed Us*, 1990, and *Shifting Ground*, 1991. In both of these images the barriers on either side of the image enclose a hubristic and failed political space. The white text stretches from one side to the other of this blank corridor of a non-place, and highlights that excluded space beyond the barriers, signified by the whitened sky. The words imposed on the images use different registers to effect the same purpose. *God Has Not Failed Us* pricks the bubble of its own rhetoric with the viciously ironic juxtaposition of text and image, the delusional victories of cultural identity against the material degradation they must make themselves blind to. The claustrophobic chasm between the building and the wall / fence, watched over by the turret and flag of Derry's walls, visually splits the photograph, replicating in its tension between text and image the desire to rupture the binary which holds together this society. The same construction is apparent in *Shifting Ground*: the two sides, the space between, and the words overwriting the image. And at first this seems like another

sardonic dig at the cultural stasis of Troubles Northern Ireland. As if the ground were really shifting. But that dead space in the midst of the image has its own slow-burning meaning. Not a nascent reconciliatory possibility, not a 'middle-ground' or third way, but a sense that mutually allergic relations of definition are obsessively self-absorbed in 'the other side' and that the continually lateral look which their binary view of the world insists on can be shaken by looking at the spaces where they meet, and shaken conceptually by looking down, by finding a way to shift the ground on which they stand. Through the ironies, constraints and failures of ideologies in Northern Ireland, and perhaps even more specifically through the abrupt severity of the psychogeography of Derry, Doherty begins an exploration of how his art can be in, and push beyond, cultural constrictions and consider the ground between and below.

Doherty's early work has occasionally been compared to that of Richard Long, and in that they both produce landscape photography overlain with semantically-freighted text, there is a similarity. Long's art of walking suggests a different mode to Doherty's and the simplicity of Long's conceptualisation of the walk can be deceptively enigmatic. Rebecca Solnit, celebrating the idea of the walker, is lured into the surface of the peripatetic in Long's work when she writes that 'the simple gesture of walking … can draw on a grand scale almost without leaving a trace'.[2] Long's texts inscribe the photographic image with words which proclaim a geometric, time-bound or nature-drawn order, and his work links the writing on the image precisely to the traces he deliberately makes on the landscape as leftovers or signatures of his presence. Long's art does not reluctantly leave a trace, it is about the traces that are left behind by the human on the landscape and about the inevitability of those traces. Even more, it is a kind of celebration of the trace as evidence of human potential, of the limitations of human consciousness and perception,

and of deeper (sometimes unfulfilled) yearnings for order. Doherty's early work may look like Long's monochrome, inscribed photographs, but its real similarity in is in the relation which comes to exist in Doherty's work between the inscription as a kind of artistic / authorial signature flourish, and the quietier enigma of the 'trace' as the sign of the presence, or the desire for the presence, of the self which can 'mark' the world.

In his analysis of Freud's short essay on the 'Magic Writing Pad' Jacques Derrida famously unravelled the logic of the trace which underpins Freud's seemingly ephemeral essay on a child's toy.[3] For Freud the marks left on the wax block under the layers of paper on the writing block are a useful analogy for the infinite capacity of the unconscious. For Derrida these 'traces' are, amongst other things, the expression of the paradox of subjectivity. They are evidence, they are physical, they are permanent. They are, in other words, everything we want the human self to be – there, real, verifiable. Yet the trace, for Freud, is constituted by the anxiety of its erasure. It desires self-presence and it worries about its disappearance. And this is our condition as subjects – we self-assert our own selves, our evidence for our existence is our existence. For Derrida this is, *inter alia*, the condition of 'writing' (again evidence of what's there and what has happened). The condition of the trace is its play of presence and erasure. The slippage from one to the other is an undermining of the common sense which says 'we are here' or 'I think, therefore I am'. The trace is evidence which makes things less certain because of its over-assertive existence as evidence, and which has us think about the 'metaphysics of presence', as Derrida calls it, the kicking of the stone to prove that the stone is there.

The inscriptions on Doherty's early photographic works already call into question their own assertiveness. They rub against the image which they apparently label, and point towards ironies and gaps in worldly logic. As Doherty's work progresses so the 'metaphysics of presence' in the work delves more deeply into those aporia opened by the juxtapositions in the earlier work. *Native Disorders I, II and III*, all 1991, dispense with the gaze across the landscape and stare down, as if in recognition that an opening up of the apparatus of meaning is possible (in the same way that Freud imagines taking apart the child's mystic writing pad, and that Derrida so keenly watches Freud's destruction of the toy). And so the words in / on the images in *Native Disorders* tend to abstraction ('LOATHING', 'DESPAIRING') and yet resound with a sense of 'form' (as in 'UNTAMED FORMS', or 'PRIMITIVE LINES'), a possibility of a timeless order-out-of-chaos. In *Native Disorders* the writing is less imposed on the image than in the work from the late 1980s – it is more as if the words have come from the elements photographed, as if a layer has been peeled off and these words found 'traced' on the land. The 'shifting ground' has been pushed aside to reveal these uncomfortable, elliptical traces beneath.

Derrida takes his notion of the 'trace' only partly from his reading of Freud. A much more important source, for Derrida, is the 'trace' as it features in the thought of the philosopher Emmanuel Levinas. For Levinas the trace, that sign of the desire for presence, can only be understood as a disclosure of alterity, a cause-and-effect remnant of the 'other'. And for Levinas this 'other' is the person who makes the self meaningful. The pre-existence of the other is the foundation of ethics, a continual, ever-present reminder of something and someone beyond and before the self. It is one of the ways in which Levinas shocks us out of our existential complacency, our sense of a centred self and a self which is, simply, selfish and constitutionally atavistic. Levinas describes the trace, appropriately in the context of Doherty's work, an as 'overprinting', a disturbing of the order of

things which is left behind. It is this trace which begins to emerge in *Native Disorders*, as Doherty looks under the surfaces of his early work to find the conceptual foundations of the cultural signs in *The Walls* and *The Other Side*. Where *Native Disorders* finds traces under the cultural process of 'othering', Doherty's later work attempts to think through a kind of ethical alternative to this cultural binarism, constructing fractured stories and disjunctive images which cut across the politics of cultural identity to become open to the tender sources of universal existence.

Levinas's trace similarly holds in balance a life lived in the ordinary world with one that is guaranteed by the strange experience of absolute alterity. His 'trace' is neither a point of warm and florid contact with alterity, nor a coming together of opposites. In 'escaping binarism', as Derrida has it, the trace etches its way into the foundations of our thought and our ethical being. It moves from the surface to the bedrock, and leaves evidence behind as a sign of a sign, a reminder of the yearning for knowledge of the Other, and for coherence and meaning. This metaphysical uncovering, carried out through charging the trace with the capacity to become 'immanent' through layers of culture and meaning, leads Levinas to imagine it as something that can be come upon in almost forensic mode. Levinas writes that the

> original signifyingness [of the trace] is sketched out in, for example, the fingerprints left by someone who wanted to wipe away his traces and commit the perfect crime. He who left traces in wiping out his traces did not mean to say or do anything by the traces he left. He disturbed the order in an irreparable way.[4]

Levinas's idea that this access to alterity has an aura of the criminal about it merely emphasises the way in which the 'trace' uncannily pierces the fabric of the material world. As a concept it chimes with a paranoia in our broken culture, something which is soaked into the landscape, or perhaps more accurately into the way we perceive the landscape (as we endow landscape with the hope of meaningful allegory). So 'place' in Doherty's work becomes a texture in and through which 'traces' emerge, never entirely being evidence of anything in particular. In *Blackspot*, his video work from 1997, Doherty is able to turn this desperation for meaning into a heightened sensory state in which surveillance becomes a kind of search for the trace of meaning and significance. Unfulfilled and fading into darkness, that flitting of the observer's eye, searching for a meaningful movement in the criss-crossing of the traffic becomes a self-reflective *form*, and one which highlights our tendency to slip into an expectation that looking will mean that we find evidence of misdemeanours. The piece reflects on Northern Ireland's culture of intrigue, confusion, deception. It also looks forward to the culture of the aftermath of the Troubles, the unfinished and haunting narratives of the 'disappeared' and, more generally, of the unresolved atrocities and brutalities of the Troubles. But it is also potentially contextless and culturally non-specific, and so is a work which thinks exactly about our yearning for traces of presence and ways to survey things and fix them in place. This itself might be said to be a legacy of Doherty's Northern Irish experiences – this knowledge of the ways in which contemporary culture will scan its sites until it can categorise matter and attach the labels which contain things.

The same might be said of the linguistic layers of a piece such as *Non-Specific Threat*, 2004, in which the desire to place and contextualise meanings is continually cut off. If *Non-Specific Threat* and *Blackspot* raise the possibility of the trace as a ghostly presence of meaning, then *Buried*, 2009, combines that forensic vision of the trace as evidence of the 'perfect crime'. Here (as in the previous and

prescient *Sometimes I imagine it's my turn*, 1998) is a crime scene, an aftermath, with fully meaningful traces which ask to be pieced back together into the narrative of an individual. What is 'buried' here is 'immanent' everywhere. Doherty himself has noted how post-Peace Process Northern Ireland, without the (flawed but potentially cathartic) mechanism of a Truth and Reconciliation Process, has become a landscape haunted by its memories, in which particular places contain traumatic stories.[5] For Freud, the trace is the beginning of understanding the return of the repressed. The traces in *Buried* may look like they point down, into the soil, to the site of a body, but, following a Levinasian (and Freudian) trajectory, they in fact point up from the soil towards us, as we try to make them meaningful. They are our memory of the false forgetting of others, whose suffering returns because we share in responsibility for it.

Ancient Ground, Doherty's most recent video work, is animated by the same principle. The 'ground' here is not seen in some archaeological/mythic way. What is 'buried' in these bogs is always potentially returning to us. It does not reassure us with the depth of our collective past. Instead it is a contemplation of the way that our culture persuades us to accept the superficial and the immediate, trapping us into choiceless coldness, like the figure at the end of *Three Potential Endings*, who becomes foetal on a concrete ramp. Doherty's art finds ways to use the surveillance and paranoia of our visually deracinated culture as a means to point to the 'traces' of human depth which inevitably return, and always remind us that another has preceded us and lived, felt and tried to tell their story as we do.

Colin Graham

1. Samuel Beckett, '9. Pour Avigdor Arikha [For Avigdor Arikha]' in *Disjecta: Miscellaneous Writings and a Dramatic Fragment* (London: John Calder, 1983), p.152.

2. Rebecca Solnit, *Wanderlust: A History of Walking* (London: Verso, 2002), p.272.

3. Jacques Derrida, 'Freud and the Scene of Writing' in *Writing and Difference* (London: Routledge & Kegan Paul, 1978), pp.196–231. Freud's original essay, the title of which has various English translations, is 'Note on the "Magic Notepad"' in Adam Phillips (ed.), *The Penguin Freud Reader* (London: Penguin, 2006), pp.101–05.

4. Emmanuel Levinas, 'The Trace of the Other' in William McNeill and Karen S. Feldman (eds), *Continental Philosophy: An Anthology* (Oxford: Blackwell, 1998), p.183.

5. Fiona Barber, 'Ghost Stories: An Interview with Willie Doherty', *Visual Culture in Britain*, 10:2 (2009), pp.189–99

WE SHALL NEVER FORSAKE THE BLUE SKIES OF ULSTER
FOR THE GREY MISTS OF AN IRISH REPUBLIC

The Blue Skies of Ulster 1986

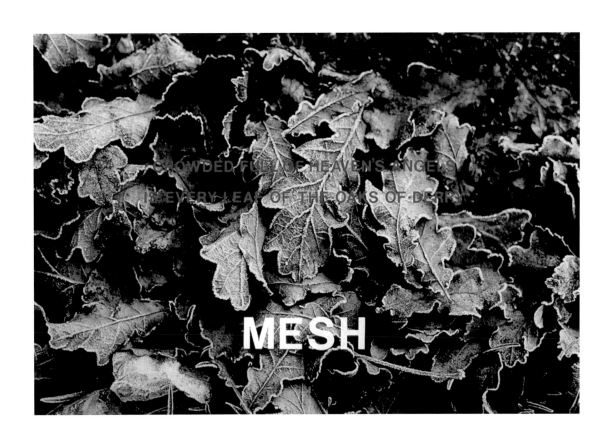

CROWDED FULL OF HEAVEN'S ANGELS
IS EVERY LEAF OF THE OAKS OF DERRY

MESH

Mesh 1986

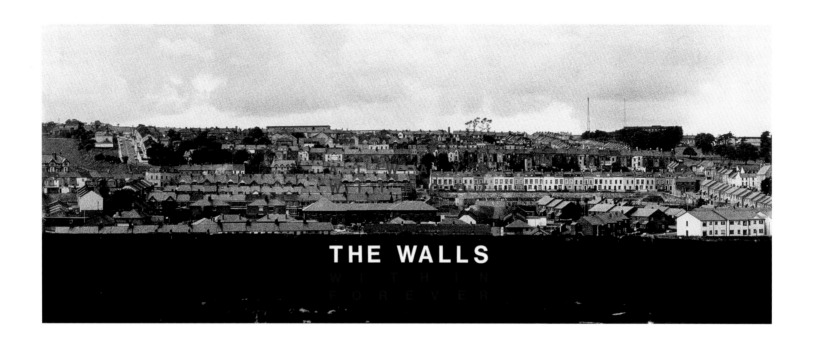

THE WALLS

WITHIN
FOREVER

The Walls 1987

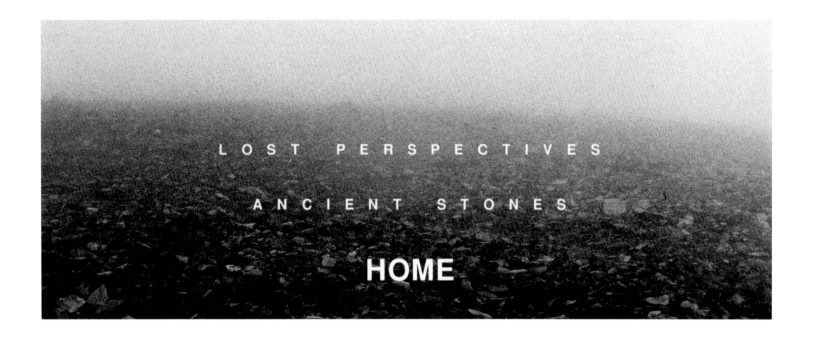

Home 1987

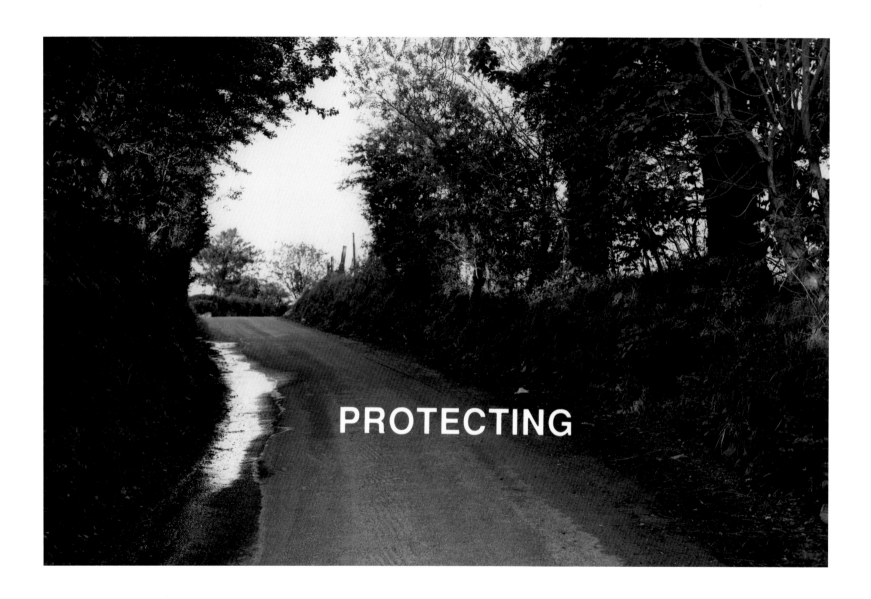

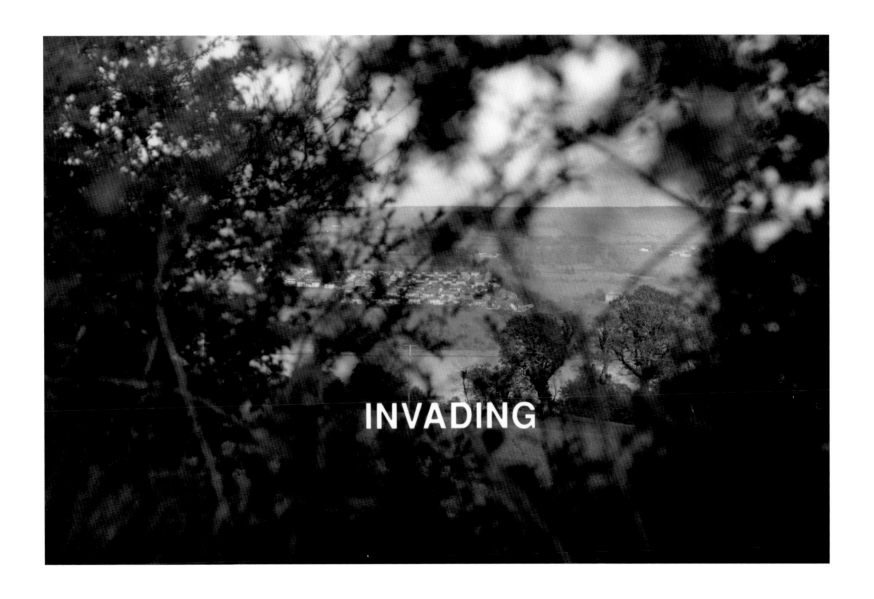

Protecting/Invading 1987

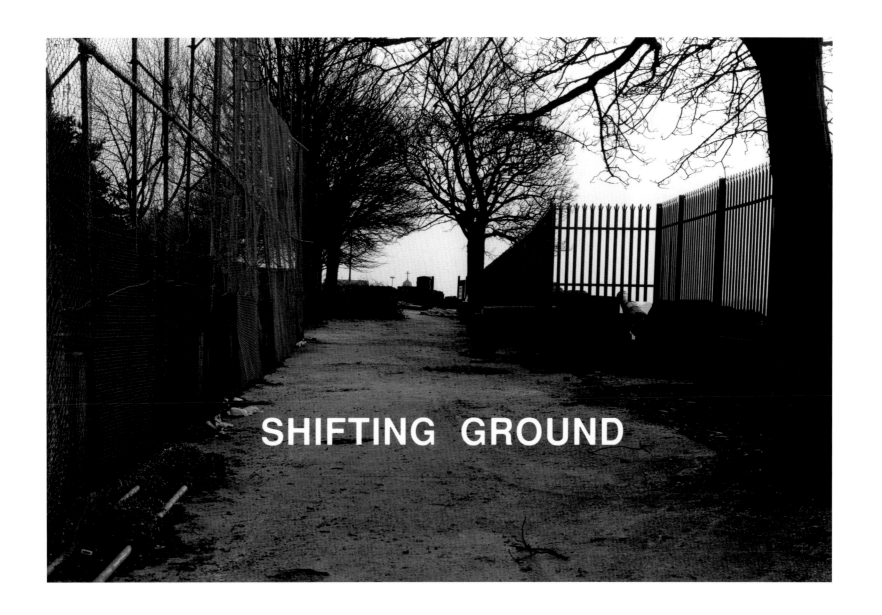

SHIFTING GROUND

Shifting Ground (The Walls, Derry) 1991

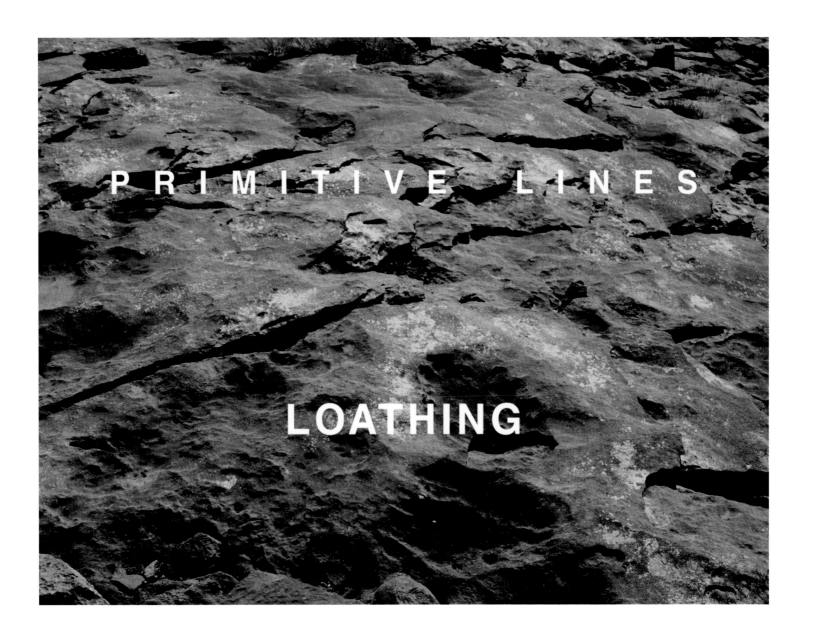

PRIMITIVE LINES

LOATHING

Native Disorders I 1991

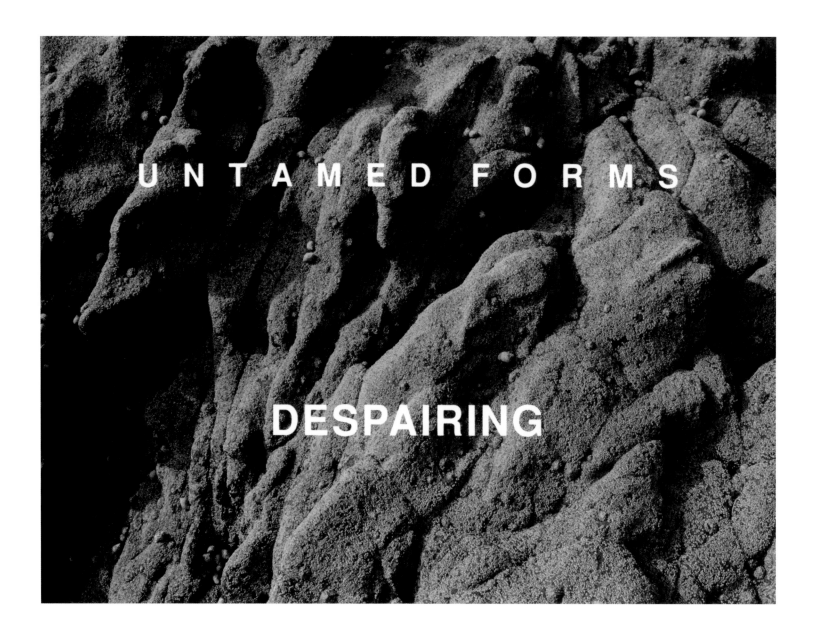

UNTAMED FORMS

DESPAIRING

Native Disorders II 1991

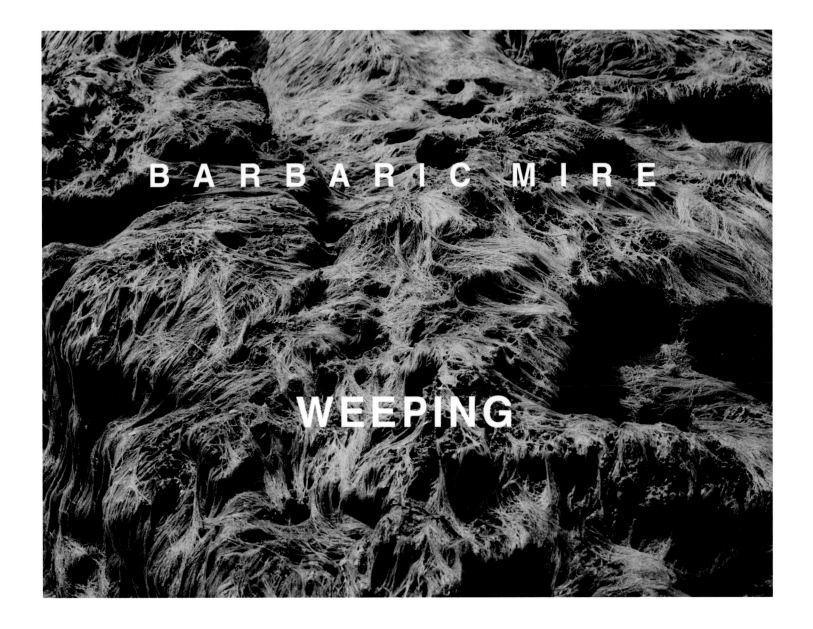

BARBARIC MIRE

WEEPING

Native Disorders III 1991

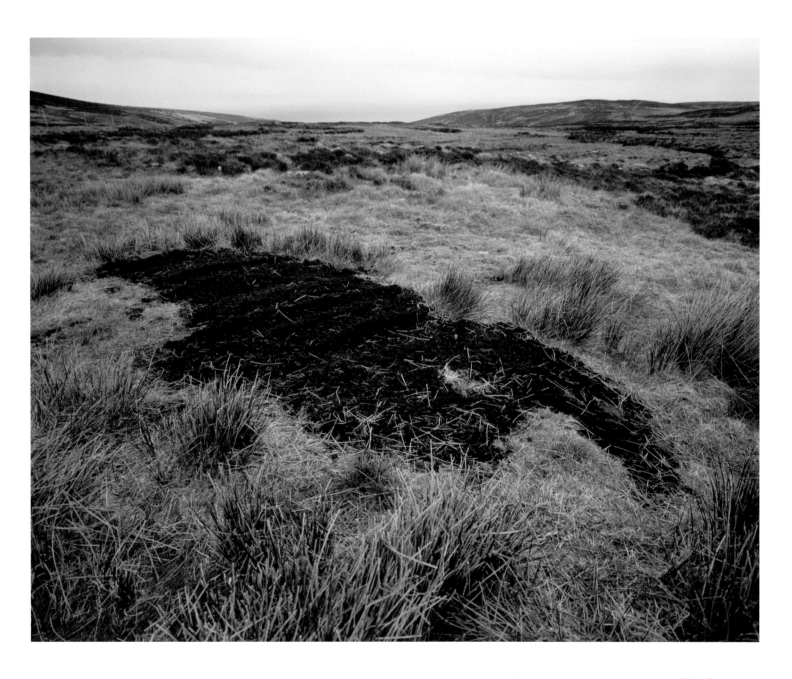

33

Disturbance 2011

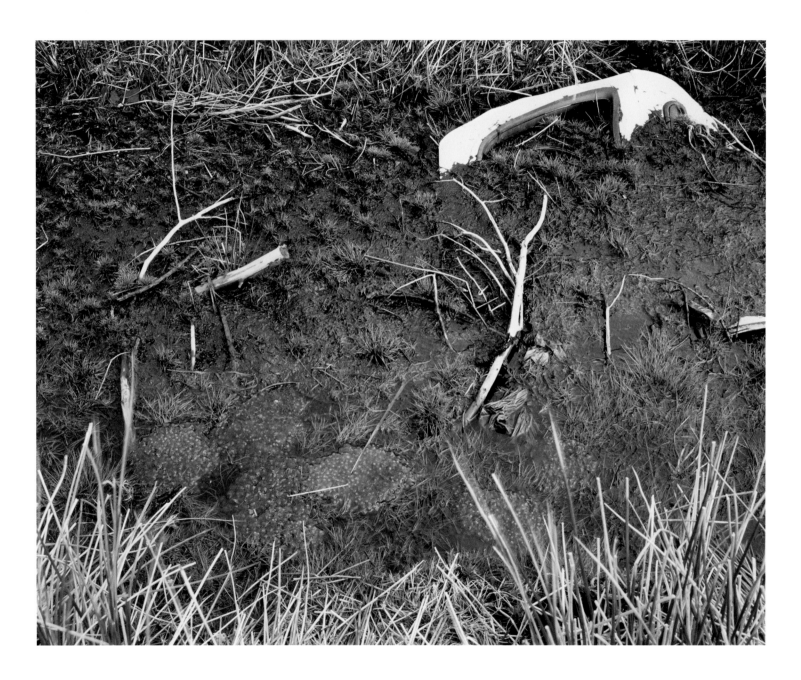

Dead Pool I 2011

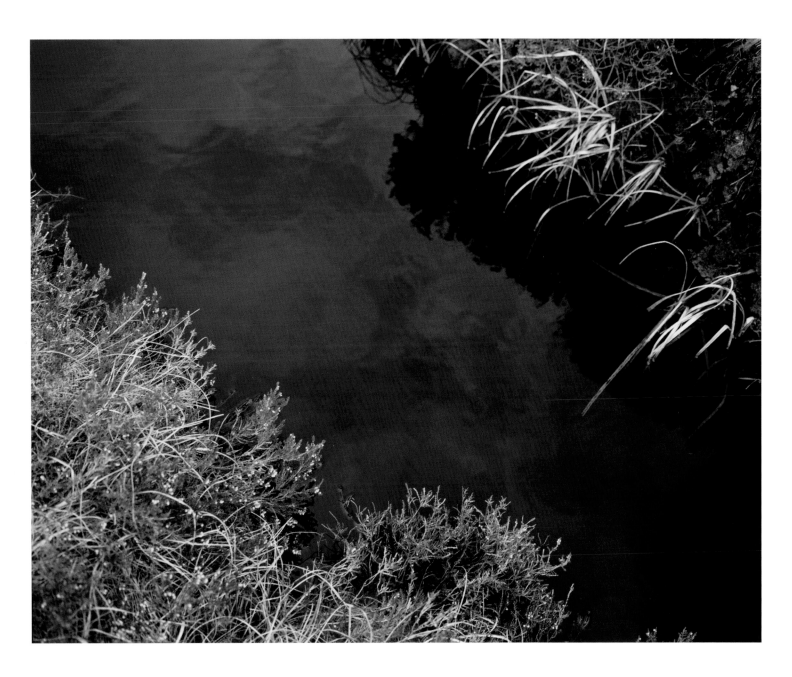

Dead Pool II 2011

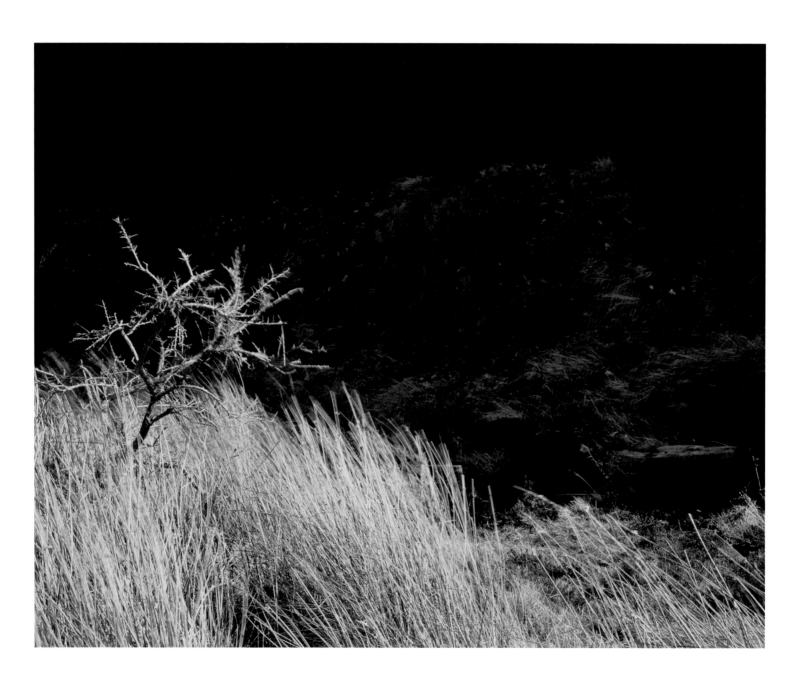

Rupture 2011

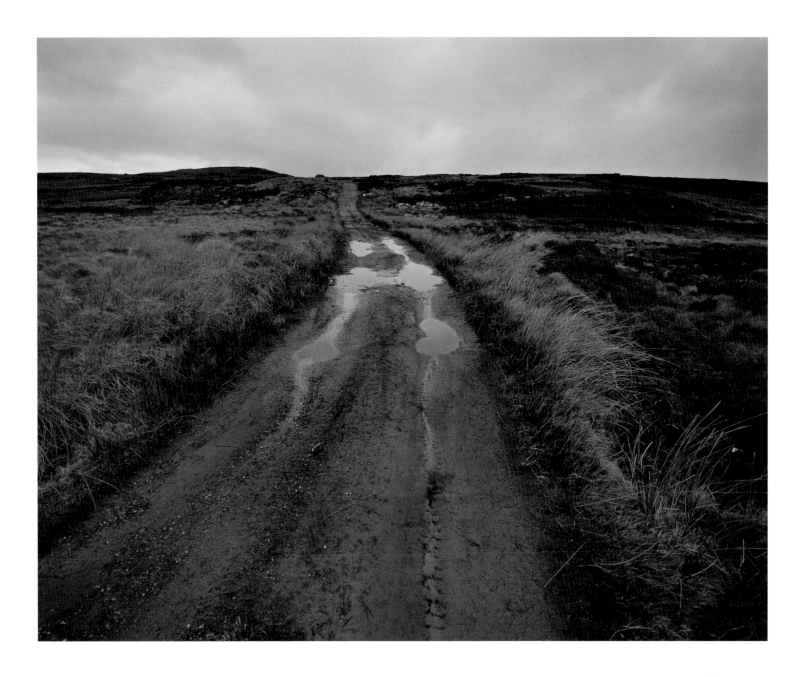

Seepage 2011

Barbara Dawson in conversation with Willie Doherty, 23 July 2011

BD: **What attracted you to study sculpture at art college in Belfast in the early 8os?**

WD: I was interested in sculpture because it presented more opportunities and possibilities to work with performance, installation and text. The sculpture course embraced working with tried and tested traditional materials and processes but also installation, time-based projects and performance. Two of the lecturers, Alastair MacLennan and Adrian Hall, who was head of sculpture and showed with the Hendricks Gallery in Dublin, were engaged with making work that dealt with the conflict in Northern Ireland through sculpture, drawing and performance. I was more comfortable with this way of working. In my first year I encountered conceptual art practices that opened up interesting ways of engaging with place, language and photography. I felt frustrated with the gap/schism between the way that art history was taught and what was going on in the streets of Derry and Belfast. I wanted to make art that engaged with the wider socio-political context.

BD: **The post-minimalist era saw artists engage with very different concerns. Who were your influences and what music were you listening to at that time?**

WD: I really became excited about art through music. My trajectory was to Punk through an early interest in Roxy Music and The Velvet Underground and consequently Andy Warhol and Pop Art. I was thrilled by the work of Rauschenberg when I first encountered it. I was and still am a great admirer of Ed Ruscha and the way he plays with image and text.

BD: **It is interesting that this exhibition, DISTURBANCE, is in The Hugh Lane at the same time as *Civil Rights etc.* by Richard Hamilton and Rita Donagh.**

WD: Yes, Richard Hamilton taught Bryan Ferry at Newcastle University.

Richard Hamilton's early work was very influential for me. It hit all the right buttons. I always saw the connection between his early work, his interest in the modern world and the lyrics of Roxy Music.

BD: **The subject matter of the early black and white photographs with text was the landscape. Issues of surveying and being under surveillance were brought to the fore. What motivated this body of work?**

WD: The early work came out of a sense of frustration with the way in which I felt that the conflict in the North of Ireland was being represented. There was a narrow strip of subject matter that was constantly used in picturing the conflict, characterised by women and children in distress and soldiers patrolling. Clichéd images. I wanted to make the underlying issues, which were more opaque, present in my work. It was more important to me to create work that contributed to an understanding of place. I wanted to create low-key images that avoided directly representing any of the more immediate signs of 'The Troubles', to make work that dealt with the everyday banality of living in Derry, not the one that was portrayed as newsworthy by visiting photographers on assignment.

BD: **These early works do have some reference to documentary?**

WD: Yes, I was interested in photo-journalism and documentary practices but felt that ultimately these lacked a degree of self-reflexivity and for me the function of the photographer as an impartial eyewitness was fairly problematic and complicated. I wanted to take photography and problematise it by implicating it in the act of surveillance. I used the camera to look at the landscape and to become a participant in the practice of surveillance. I could walk in Derry and along the border with Donegal with my camera, aware of being under constant surveillance while also engaging in a parallel

act of looking. It became a powerful way of responding to the sense of being rendered powerless by being under surveillance.

BD: **It is a huge psychological pressure.**
WD: Absolutely. It feeds into paranoia. The fear of random violence, feeling that you could become a victim, being in the wrong place at the wrong time. This was something that everyone lived with but it was never talked about. Making this work was a personal resistance to feeling like a victim. I chose to live in this place and so I had to resist that, otherwise why would I live here?

BD: **Making this work requires a persistent looking at the landscape, starting in your own city, Derry.**
WD: Derry is quite a small place – I often think of it almost as a stage set; a theatre of war. It has the walls and the River Foyle – East bank and West bank and the proximity of the border with the South of Ireland. I have a mental map of the city. It is very clear that the city has been planned in a strategic way that takes account of the features of the landscape. It is easy to visualise the power relationships in Derry being played out within the terrain.

BD: **This 'Theatre of War' provided the subject matter for the first body of your work. How do you respond to it today?**
WD: Having the black and white photographs in this exhibition is a good time to look at that body of work again. It is timely that a group of the very early work is been shown alongside the most current work. It is interesting to see that my concerns with reading the landscape are still present in the work that I am making at the moment.

BD: **And the use of language?**
WD: When I look back at these works I really like them. They have acquired a quasi-historical status over the years but at the time of their production they really were very specific and required some previous knowledge of history and the political situation. They are quite stubborn. As I began to exhibit the work more widely in the 90s I thought that this was becoming problematic so I started making black and white photographs without text and then the cibachromes.

BD: **The first work we bought for The Hugh Lane was *At the Border II (Low Visibility)*, 1995. While its subject matter, the landscape, was still your priority, it was a departure from your black and white photographs with text from the late 80s which first brought you to prominence.**
WD: *Low Visibility* is a good example of how the work shifted to become more open and less dependent on the specifics of place that were activated by the text. Instead these works co-existed in relation to other images of terrorism and conflict. What is terrorism supposed to look like? How are such things visualised for us? I was interested in the overlap between fictionalised accounts of such events from cinema, television news stories and photo-journalism. In the context of the broadcast media ban that was imposed by the Thatcher government to restrict how events in the North could be represented and spoken about, I became interested in what the conflict looked like and how it was spoken about.

The strongest stereotypes of what the terrorist looks like continue to fascinate us, for example the glamour of the Baader-Meinhof Gang, the unknowability of the perceived threat from Islamic terrorism and the irrationality of the lone gunman, as we have seen today in the attacks in Oslo. It is significant that the individual responsible for the horrendous events in Oslo decided to make a car bomb. The car bomb is the most familiar weapon of terrorist groups globally. He then acted as the lone gunman, most familiar to us from shootings in the USA. This man appears to have absorbed all of the ingredients of what a headline-grabbing attack should look like. The biggest

terrorist incidents are often referred to as 'a spectacular'. What I became interested in with the cibachromes was the relationship between real events and how they were mediated. *Low Visibility* is concerned with the potential that the photograph generates between an act or an intervention in a place and its aftermath.

BD: It also had a strong formal aesthetic.
WD: It is very constructed in terms of lighting and camera viewpoint. All my photographs are made in real places. I rarely stage things but I do frame them carefully and use light to enhance this sense of the image oscillating between fact and fiction, staged or real. Jeff Wall uses the term 'near documentary' to refer to a strand of his photographic work. It is a useful term to bear in mind when thinking about the status of these works in relation to documentary photographs and cinematographic staging.

BD: Returning to the early works, how did you choose your texts?
WD: I appropriated some texts from various sources, such as graffiti, political speeches, sermons, and others I wrote directly in response to the photograph. I noticed that many of our finest politicians were fond of a good metaphor that evoked the mythical Irish landscape. The phrase 'We will never forsake the blue skies of Ulster for the grey

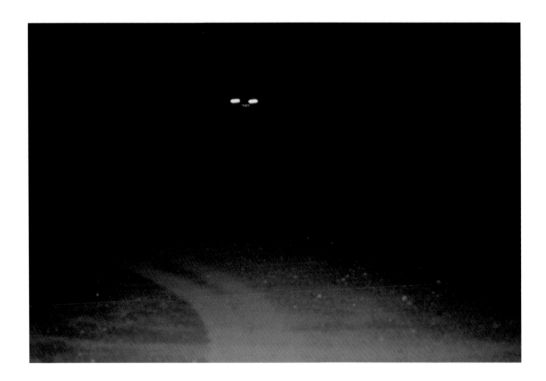

At the Border II
(Low Visibility) 1995

Cibachrome photograph, 122 × 183 cm
Collection Dublin City Gallery
The Hugh Lane

41

mists of an Irish Republic' is a perfect example of this. I think it was used by Ian Paisley. 'The other side' is another, referring both to the other side of the river in Derry, as represented in the photograph, and to the vernacular use of this phrase to speak disparagingly about someone who belongs to a different religion from one's own – 'He's from the other side'.

I was concerned with using the minimum amount of words to convey something of the complexity of the situation. *Home*, 1987, is a photograph taken on the top of Muckish Mountain in County Donegal on a particularly wet summer day. This work nods in the direction of some of the other images of the West of Ireland, for example the paintings of Paul Henry that evoke an untroubled and uncomplicated vision of the land. It's significant that they have been used by Bord Fáilte as a representation of the quintessential idealised Irish landscape. Contemporary landscape artists like Richard Long and Hamish Fulton have also made work in the Irish landscape. They have a particular rationale and way of looking which leaves unanswered any ideas of the landscape as a social and political construct. I wanted to have a strategy to address these concerns and return something of that sense of complexity.

BD: **Was the Orchard Gallery important to you at this time?**
WD: The Orchard Gallery provided a great and welcome opportunity to see work that I otherwise wouldn't have seen. There had never been anything like this in Derry. There was also ARE (Art and Research Exchange) in Belfast, which showed interesting and engaging work when I was a student there. It grew out of the impetus of Beuys' visit to Ireland in the 70s. I was privileged to show at both spaces in the 80s.

BD: **You also exhibited with Oliver Dowling in Dublin in the 80s?**
WD: Yes, I met Oliver at the Orchard Gallery in 1985 and we got

talking. I showed him the first versions of photographs with text that I was working on and he invited me to exhibit with him. I had my first exhibition at the Oliver Dowling Gallery in January 1986.

BD: **How was the exhibition received?**
WD: I received a very positive response to the show. There was also a good critical response to the work and things took off from there.

BD: **You have been shortlisted for the Turner Prize twice, in 1994 and 2003, and have represented both Ireland and Northern Ireland at the Venice Biennale, in 1993 and 2007 and Great Britain at the São Paulo Biennale in 2002. While there can be no doubt that you draw on your local experiences for your work, there is, however, an inherent universality about it that transcends the specific. One of your early experiences of the conflict was Bloody Sunday in 1972.**
WD: It was a traumatic event that has affected the lives of so many people. The most immediate impact on me was the realisation that I had seen something happen with my own eyes that was subsequently denied, and that in itself revealed a particular relationship with the State. I was appalled at the initial inquiry, at the whitewash. All the evidence of what happened on the day was disregarded and another story was invented. It had an impact on my relationship with the media … nothing could be taken at face value. I understood, as a child, for the first time the wide sense of frustration, of being disenfranchised from a political process.

BD: **When did you start to make videos and how did they come about?**
WD: I stopped making text-based works in 1991 and started working on photographs. I was starting to consider working with video at this time and so I think this had an impact on the photographs. I thought of the photographs as film stills, images that were disconnected

from the larger narrative of a movie. There was something about the shared nature of the cinematic experience that fascinated me. I was interested in the genres of horror and the thriller and how constructed they are in visualising our worst fears, our nightmares and their relationship with the dark. Fear of what can't be seen and of what might be out there. Fear of the unknown. I questioned the relationship between the use of reconstruction in dramatisations of real events and the familiar tropes of the horror movie. What does the terrorist look like and how is terrorism represented? What stories are told around our fear of a violent death? I started to make photographs alone at night, in the dark. In *Low Visibility* it is hard to see all of the landscape; you can't quite negotiate the space. You're not sure of it.

In 1993 I made my first video, *The Only Good One is a Dead One*. It came about from an experience I had when I began teaching in NCAD (National College of Art and Design). I had just started to drive and I would drive from Derry to Dublin either very early in the morning or else late at night. One night, driving home, I was listening to the radio and heard a news report of a random sectarian killing. A loyalist paramilitary gang, dressed as a UDR patrol, stopped this guy in a car and murdered him. I was freaked out by this incident. I then began to think of the possibility of using my fear to create a work that would use my conflicting responses to this incident to create two overlapping stories or characters that could be articulated within one voice. The work basically consists of two point-of-view shots. The first part is shot through the windscreen of a car that is driving around small country roads at night. The scene is lit by the headlights of the car. In the second part the car is parked on a city street. So you have this sense of observation and surveillance. The voice-over uses the same voice for the two 'characters'; the perpetrator and the victim. Conventionally, you would have two separate voices but I collapsed them into one in this work. The perpetrator could also be the victim. The victim has thoughts of revenge. It throws up the complexity of the status of victim and perpetrator.

BD: The titles have implications, as, too, does the insistent repetition of the story within the imagery?

WD: The phrase 'The Only Good One is a Dead One' gives no presumption of innocence. They must be guilty. When I was planning this work I knew that it had to be made with the moving image that it couldn't be a still photograph. The duration of the work is thirty minutes. The two sequences of images shot from the car are in real time and unedited. The spoken monologue repeats every ten minutes but the real-time imagery shot from the moving car repeats at a different rate and is out of sync. The car is also driving in circles. The sequence shot from the car on the street appears to be static but is constantly changing as cars and people pass by. These different levels of repetition in both the imagery and the text are central to the work. It becomes a closed circuit. The action is caught in a cycle of repetition and the imagery is constrained within the repeated text.

BD: *Non-Specific Threat*, 2004, also examines the use of language and the image of victim/perpetrator?

WD: Yes, it was shot at the end of 2003 in the lead up to the second war in Iraq. I was interested in the language used by Blair and Bush in creating a context for going to war. Weapons of Mass Destruction (WMDs) were supposed to be a real and present threat. Then when they failed to materialise the language shifted to incorporate a non-specific threat. So the language got more slippery as the push for war increased. I was reminded at this time of the way in which language itself became part of the battleground during the years of the broadcast media ban. I often think of what happened in the North of Ireland as a model or a case study for how governments might

think about their responses to terrorism. Unfortunately, the lessons don't appear to have been learnt. The failure of the position that 'we don't negotiate with terrorists' is obvious. It insists that terrorism is beyond language and beyond reason. Subsequently, in the North we had talks about talks, actual talks and then the Peace Agreement. The text of *Non-Specific Threat* is written around the perversion of language that politicians deploy to instil fear. I wanted to play around with visualising the terrorist, visualising the non-specific threat and putting words into his mouth. I wanted to reveal the inherent ambiguities and complexities. The actor is Colin Stewart; I chose Colin because he was typecast by the BBC for their re-enactment of the Holy Cross incident in Belfast. Colin was cast as the ringleader of the violence, the paramilitary skinhead thug.

BD: How is *Non-Specific Threat* constructed?

WD: *Non-Specific Threat* is constructed using a 360-degree pan. The viewer is invited to scrutinise every aspect of the figure as the camera moves around him. He is offered up for inspection in an almost forensic way but at the same time you lose sense of where he is. He appears to be inside some kind of warehouse but then you see trees, so maybe he is outside. You are not really sure and this destabilising shift creates a sense of insecurity and menace.

BD: What is it like to work with professional actors?

WD: There is an intensity working with actors. I don't come from a theatrical background and I had no prior knowledge of directing. I am interested in what happens during a shoot. Something has to happen in the moment that makes it convincing. Because my works are unscripted at the time of shooting, there is no point of reference that comes from a text. Most actors want to know what you want from them. So when Colin asked me, I said, well, just think of the typecast character the BBC wanted you to be and act accordingly.

Something amazing happened during that 360-degree scrutiny: the various expressions – slipping into character – menacing – and then moments when he looks vulnerable. For me, the relinquishing of control and trusting that something will come out of the performative moment are the interesting things about working with actors.

BD: Do you write the texts yourself and which comes first, the imagery or the text?

WD: The imagery comes first and then the text. The work always starts with the location. It's usually a place I am aware of and I need to go back to again. The video works are usually based on some kind of intervention with a camera and/or an actor in a specific place.

BD: How do you identify a place?

WD: Initially I see a place from a bus or driving by or when I go walking. I am interested in these different ways of encountering and moving through a landscape. I like the pace of exploring a landscape by walking, which perhaps goes back to my early interest in the work of Richard Long and Hamish Fulton. The opening line of *Ghost Story*, 2007, is 'I found myself walking along a deserted path'. I am really an old-fashioned landscape artist!

BD: The Hugh Lane's most recent acquisition of your work is *The Visitor*, 2008, which I thought was fabulous the first time I saw it. There is a certain poignancy about it, a strong sense of memory and something passing.

WD: Yes, like *Ghost Story*, the work attempts to deal with memory at a time when we are being asked to forget the past. *The Visitor* started something that has continued with my most recent work, *Ancient Ground*, 2011 – the idea of scrutinising or looking closely at a place using a static or slow panning camera in the hope there is some residual material to be found there.

BD: **The same sense is in *Buried*, 2009.**

WD: Yes. In *The Visitor*, *Buried* and *Ancient Ground* there is a sense of the camera searching the material evidence that is to be found in each location. I want my use of the camera not to be too interventionist, to allow the place to do the talking. The camera acts as a kind of witness, a counterpoint to amnesia.

BD: **What is the shift between the opening sequence and the more staged middle section of *Buried*?**

WD: The opening sequence begins in daylight but as the camera moves deeper into the woods then there is a transition into other space, one that is more familiar from the horror genre as the lighting and sound change. Finally the work returns to a more naturalistic representation of the landscape.

BD: **This is the point where the exhibition pulls back to the early work.**

WD: There is a logic to looking back now. *Ancient Ground* is closely related to the early works; the imagery largely consists of a sequence of static shots and the voice-over functions as an equivalent to the text superimposed on the photograph. There is something in the way I have constructed the text using short phrases that reminds me of the early work. How the text and the imagery in *Ancient Ground* speak to each other reminds me of the configurations of text and imagery in the early work. My enduring interest in how the stories of specific places get told and my use of language to disrupt conventional readings of the landscape provides a logic for this exhibition.

BD: **My final question is about *Segura*, 2010, which is not set in Northern Ireland but in the south of Spain.**

WD: *Segura* was made in Murcia in the south of Spain in the context of *Manifesta 8*, the European Biennial of Contemporary Art, which in 2010 sought to address issues around Spain's relationship with North Africa, immigration and unemployment, as well as regional and global issues of water shortage and pollution. How do you embrace these issues? I thought, at least these are real issues, so there must be evidence of them in the place. I trusted myself to find them. My strategy was to walk in the city, the landscape, trusting that some evidence of these issues would reveal itself. I look at a city, a location and see what it offers up. What traces people leave behind. *Segura* comes out of the working methods that I developed in Ireland. If I look I'll find what I need to find. Years of experience help me to make such a work. I can trust my judgement. I found evidence of illegal immigrants from North Africa who may have had work at one time but now are homeless, living underneath a bridge beside the river Segura.

BD: **Circularity of movement is a very strong metaphor in the work?**

WD: This circularity and repetition doesn't offer hope for a beginning, middle or end. In a way the circularity becomes a metaphor for entrapment.

Ancient Ground

2011

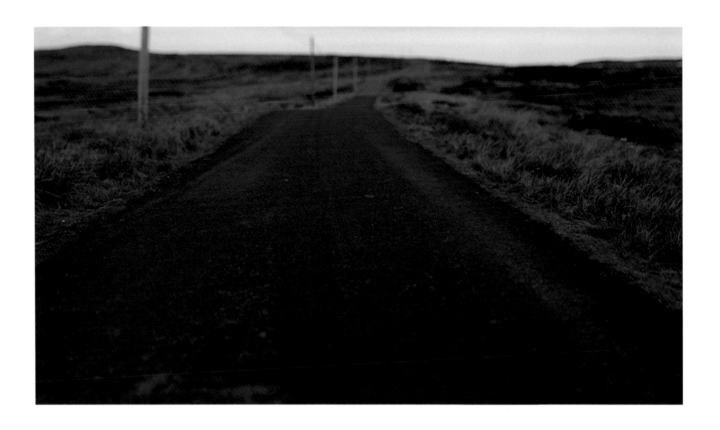

I walk these roads every day.

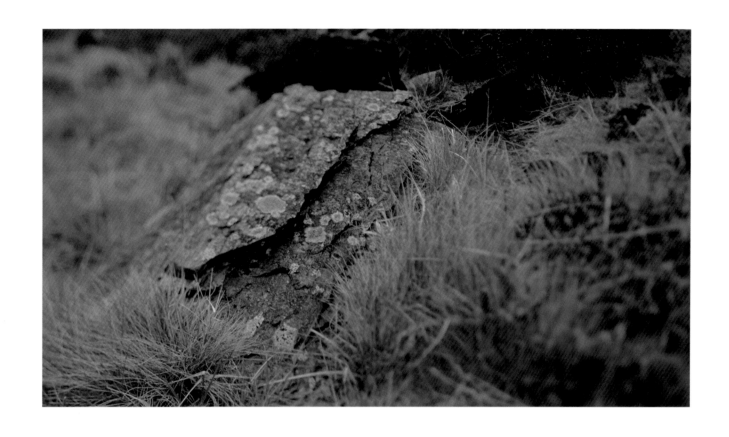

The ancient ground.

Looking for a sign.

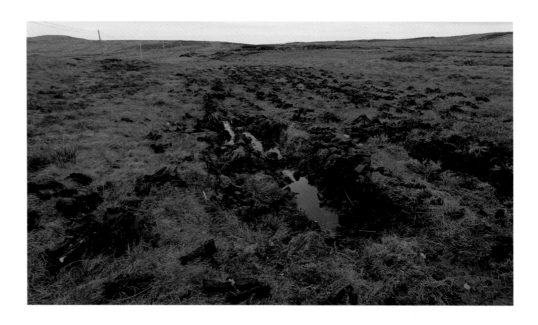

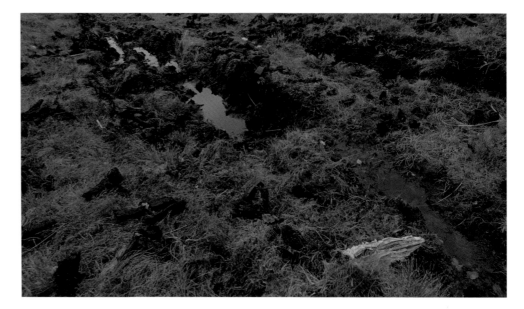

Some disturbance.

Something shifted.

Revealed.

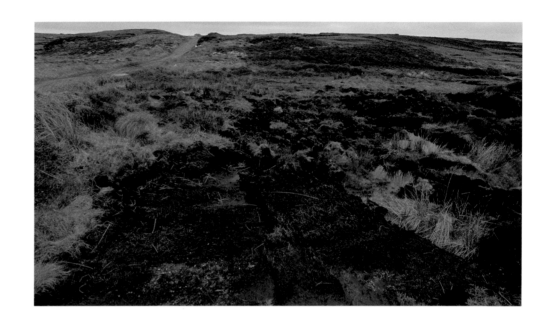

Given up.

Leaking.

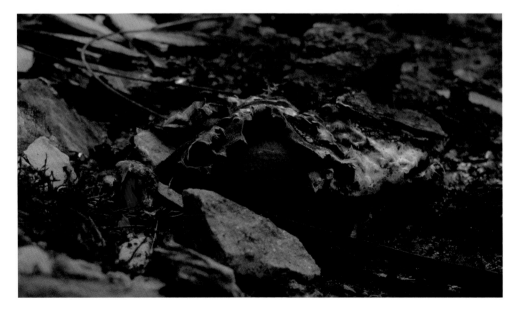

The black mould.

The misery.

The loneliness.

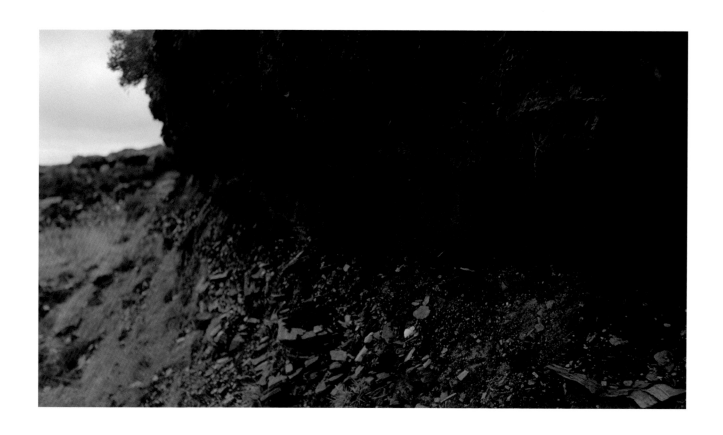

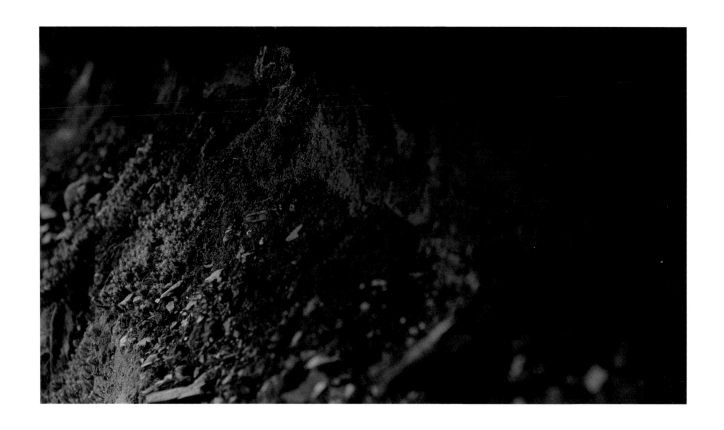

The darkness.

The restless struggle.

The elements.

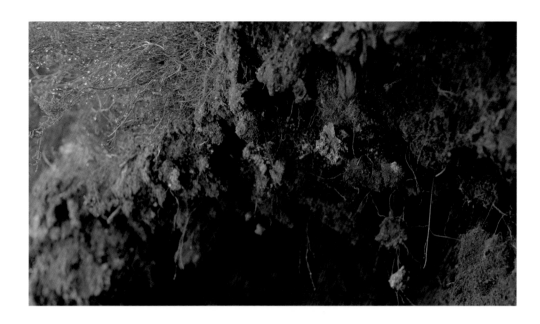

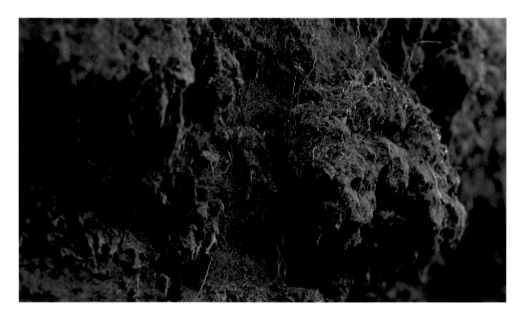

The seasons.

The passing years.

The whispers.

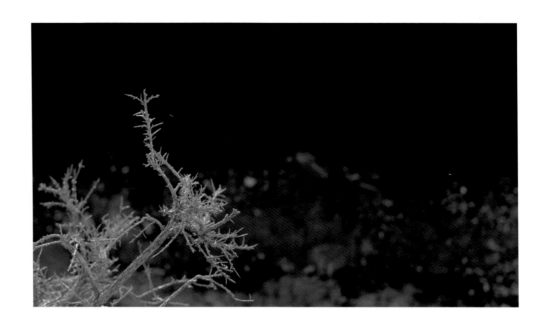

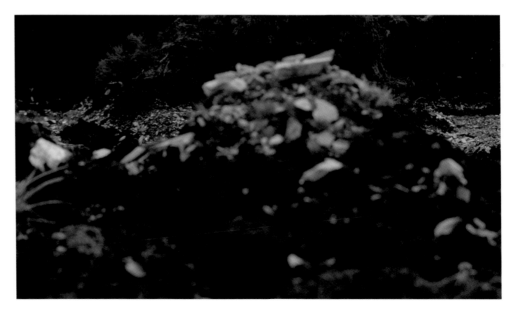

The shame.

The punishment.

Beyond words.

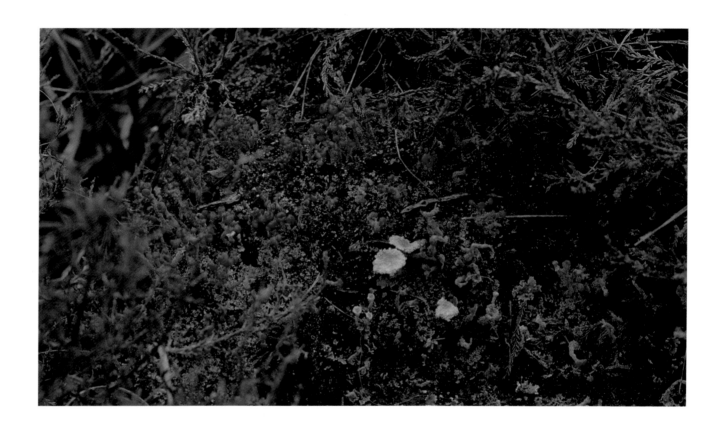

The sin.

The pride.

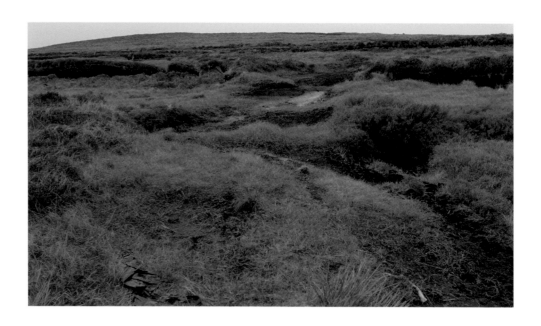

The honour.

The revenge.

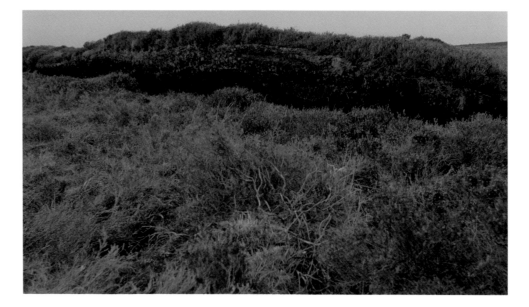

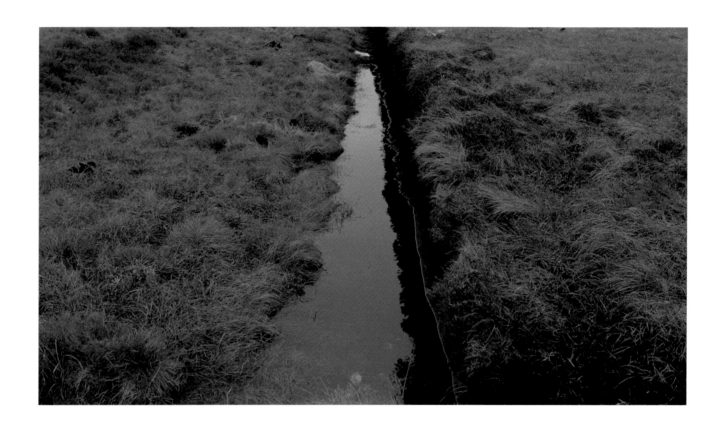

Hooded.

Bound.

Weighted down.

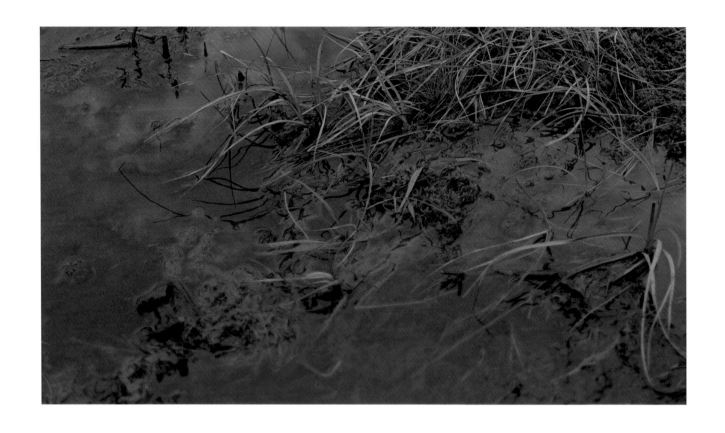

Discarded.

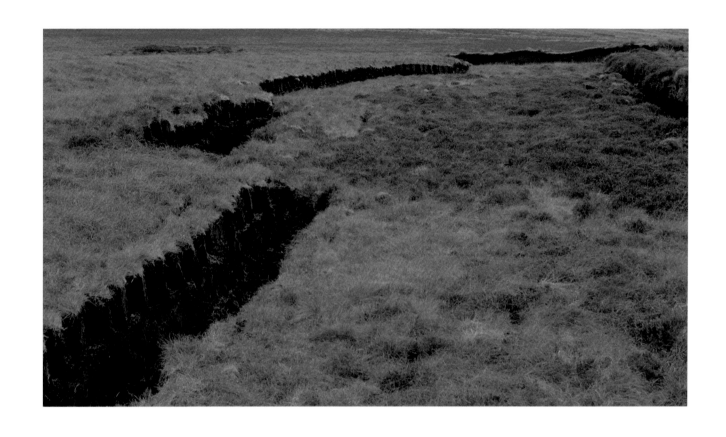

Unmarked.

The callousness.

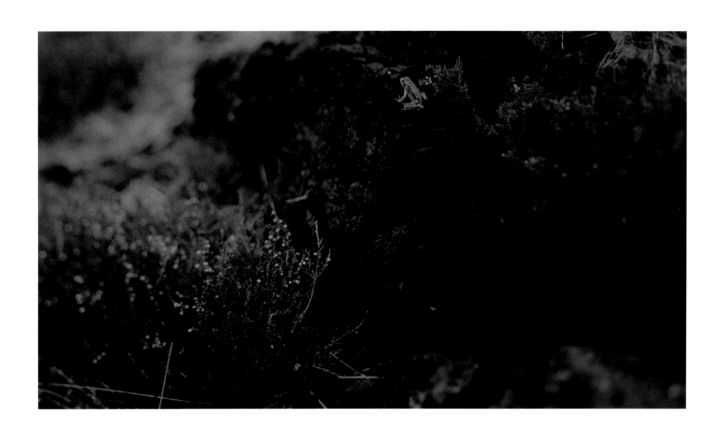

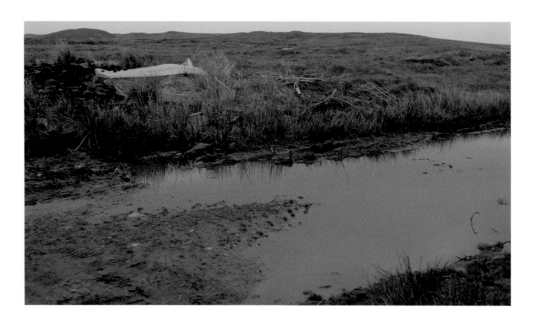

The concealment.

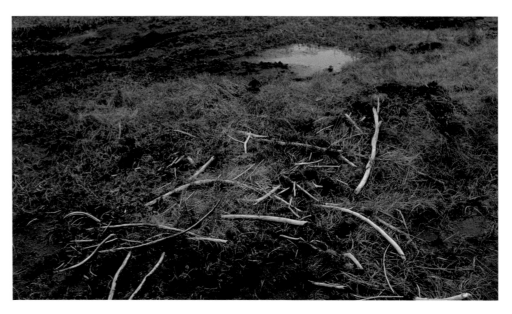

63

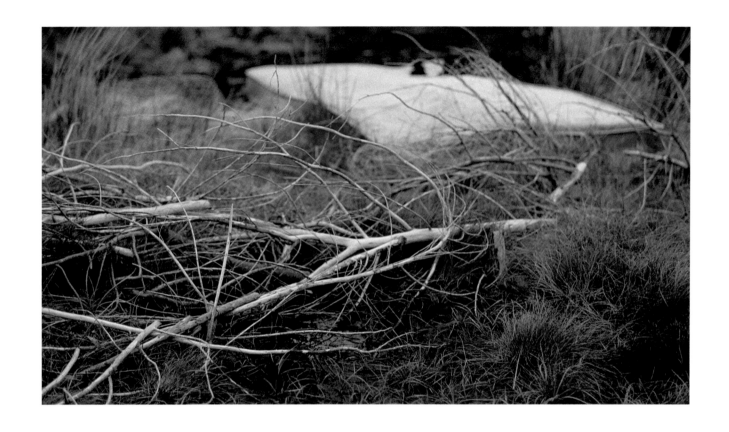

The fingerprints.

The dental records.

The femur.

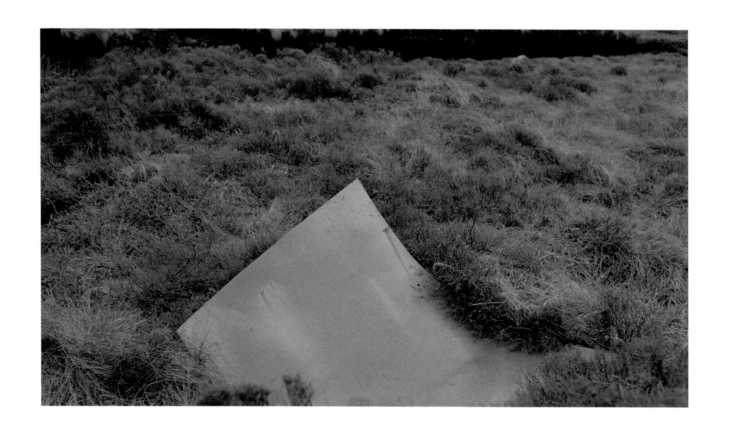

The jaw.

The ribs.

The fibula.

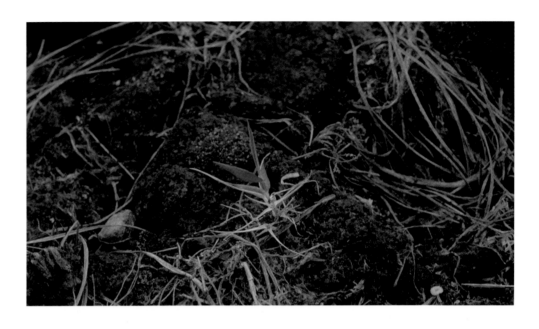

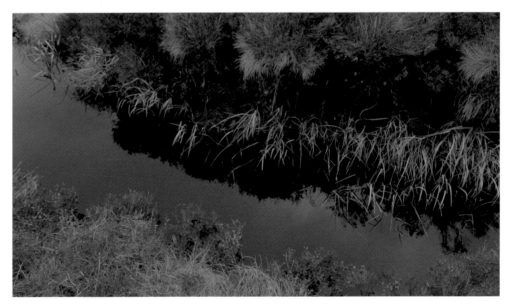

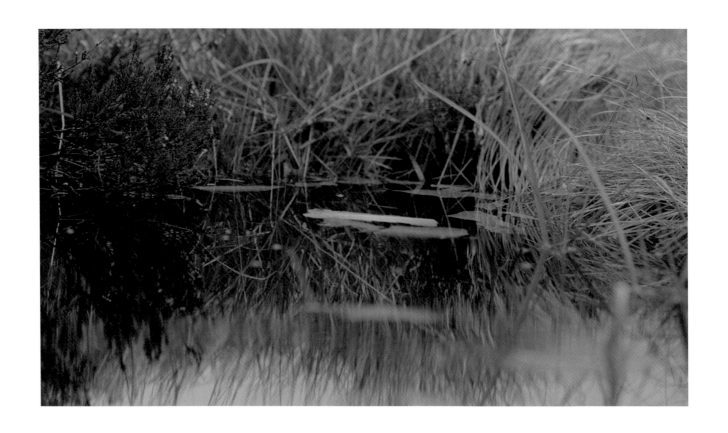

Preserved.

The hair.

Compacted.

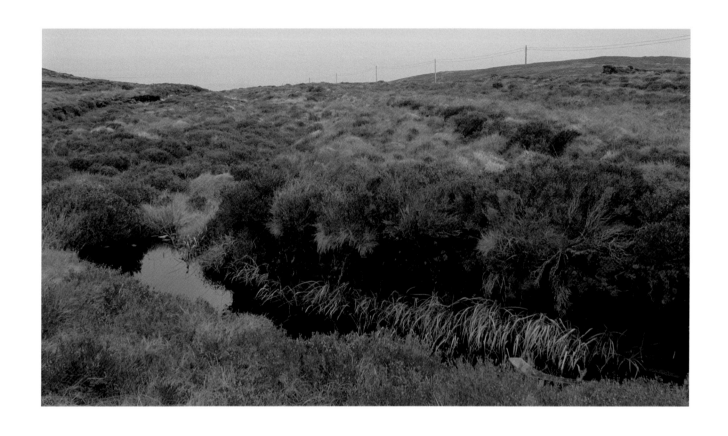

Out of sight.

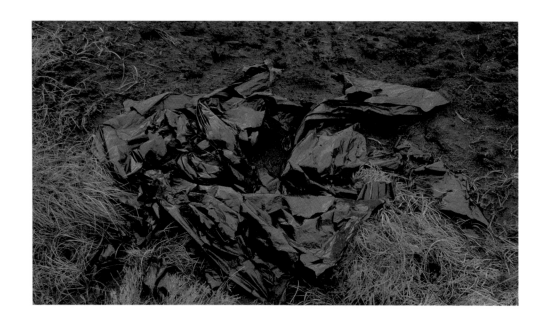

Invisible.

Pressed down.

Between the layers.

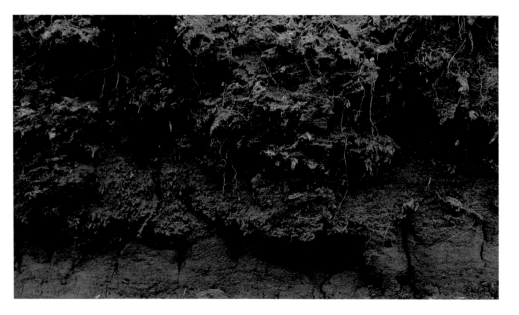

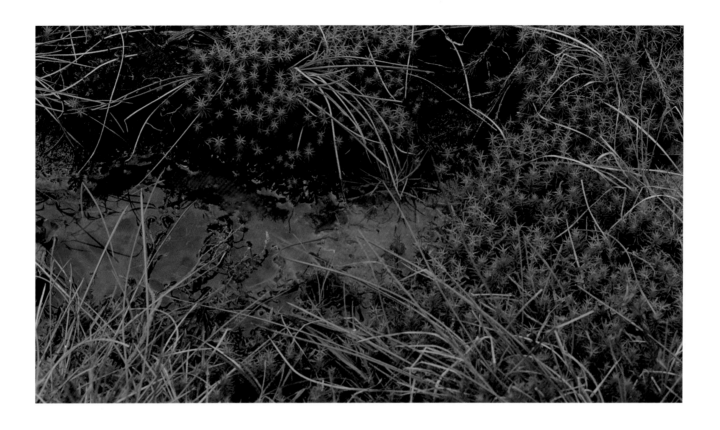

The seepage.

The vapour.

Formless.

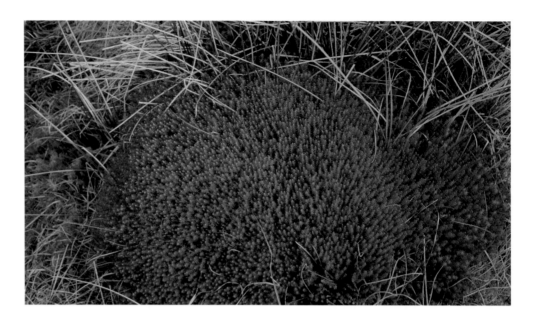

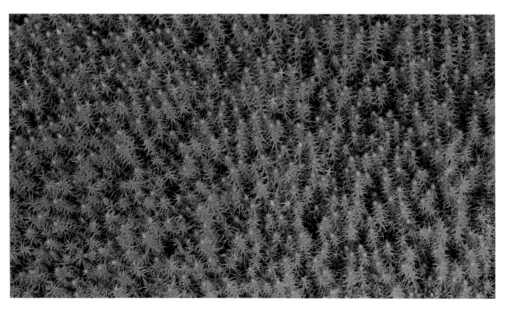

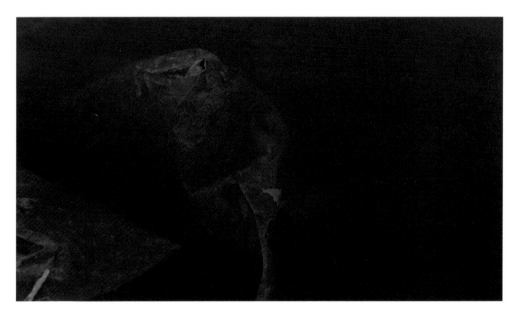

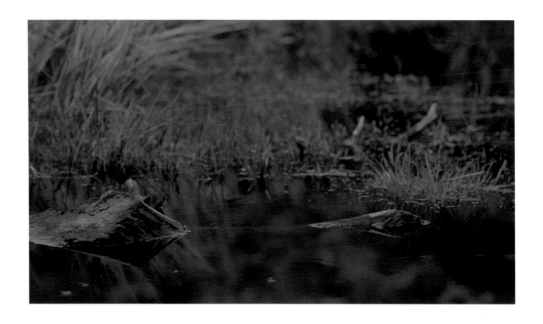

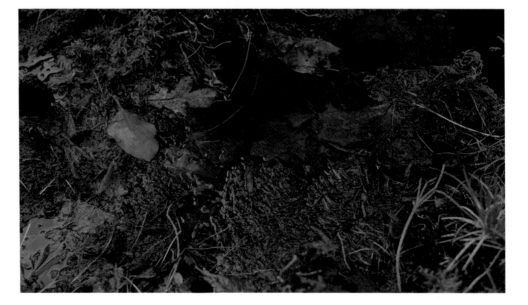

The small details.

Half remembered.

The dank smell.

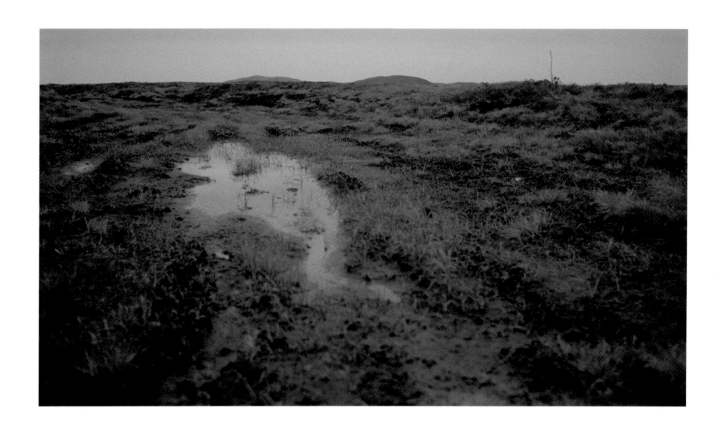

The forgetting.

The regret.

The silence.

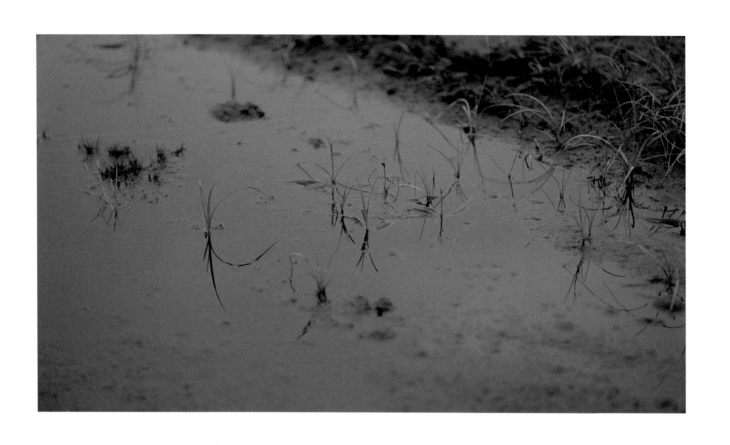

Segura

2010

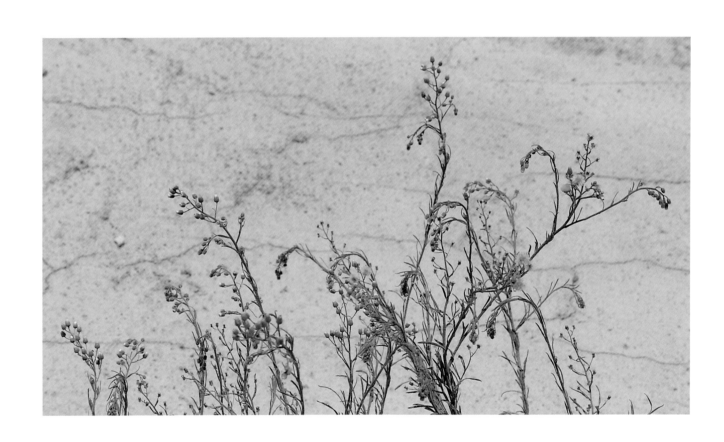

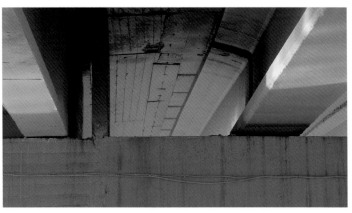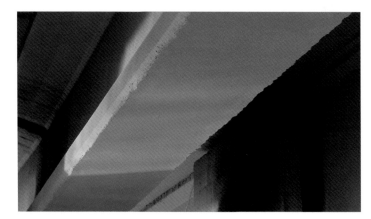

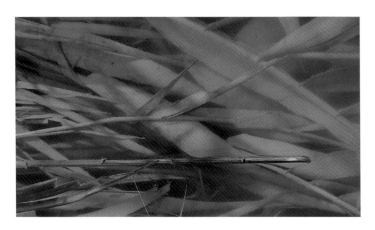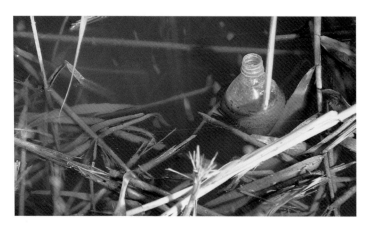

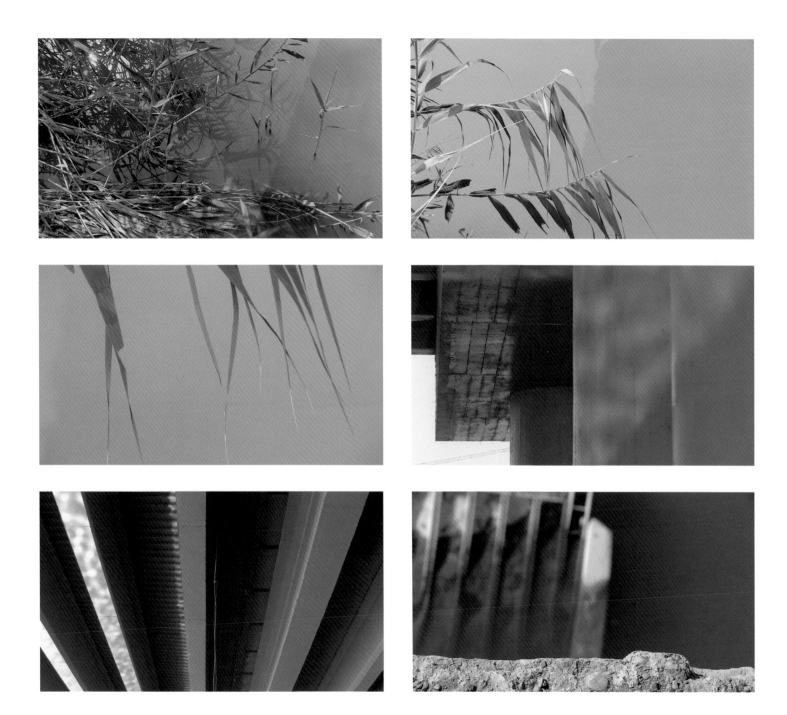

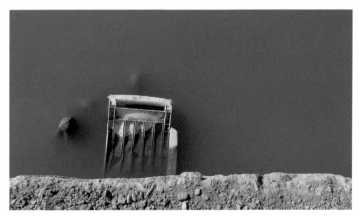
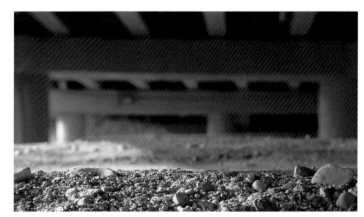

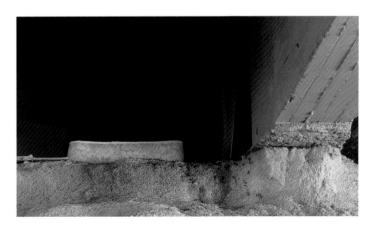
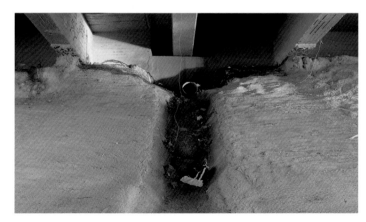

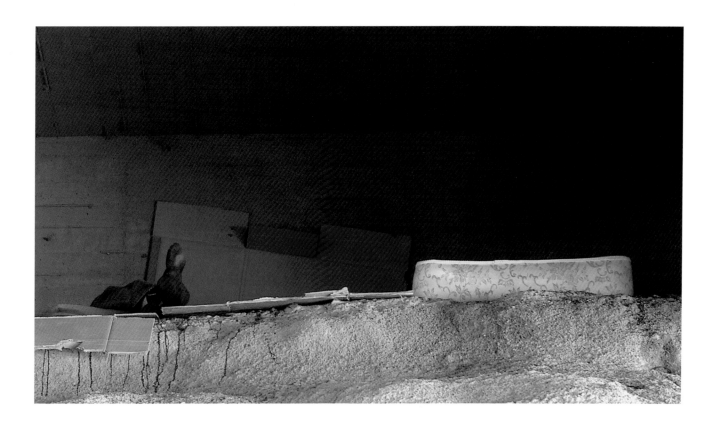

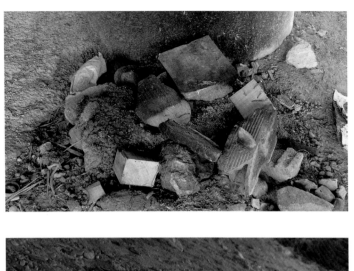

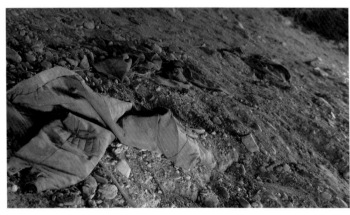
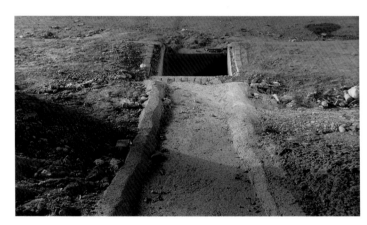

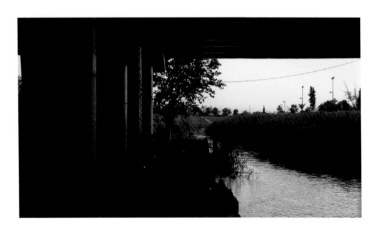
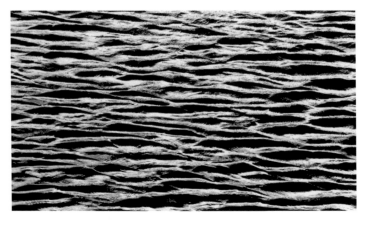

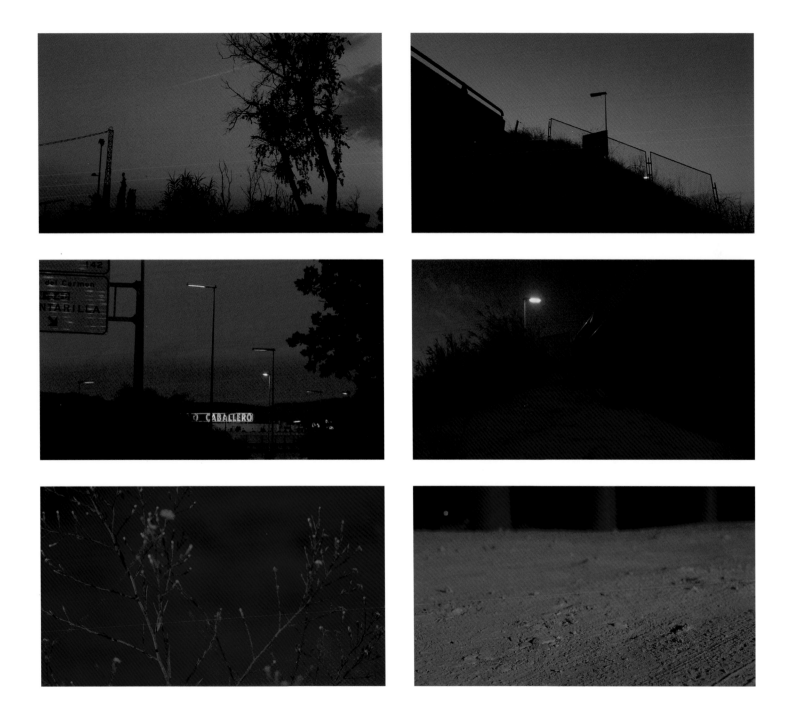

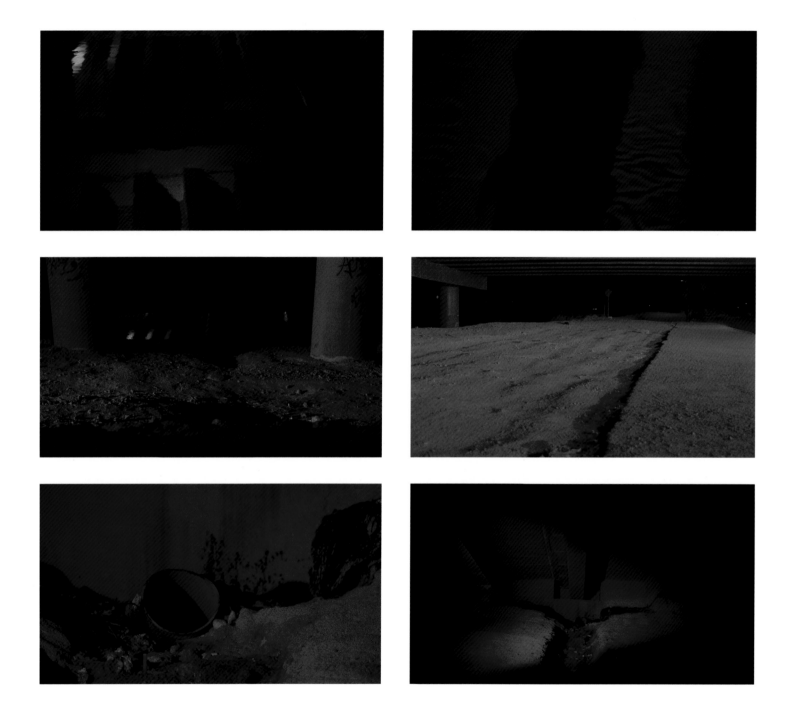

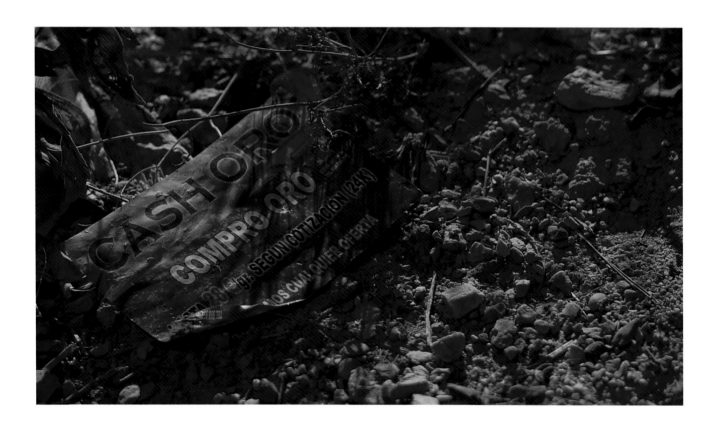

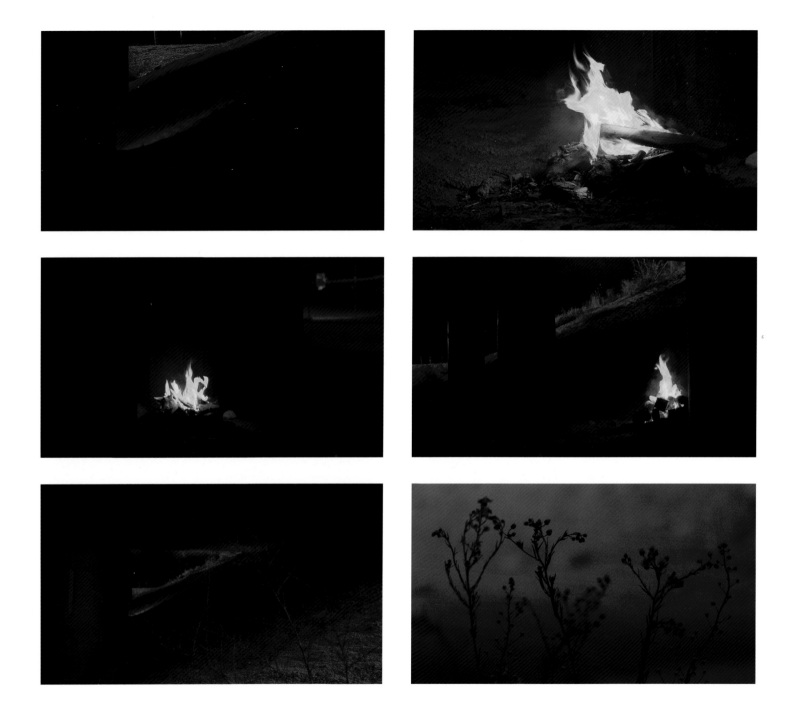

Buried

2009

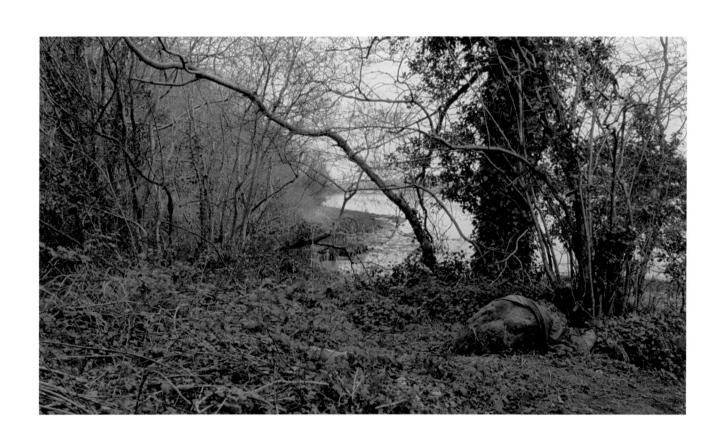

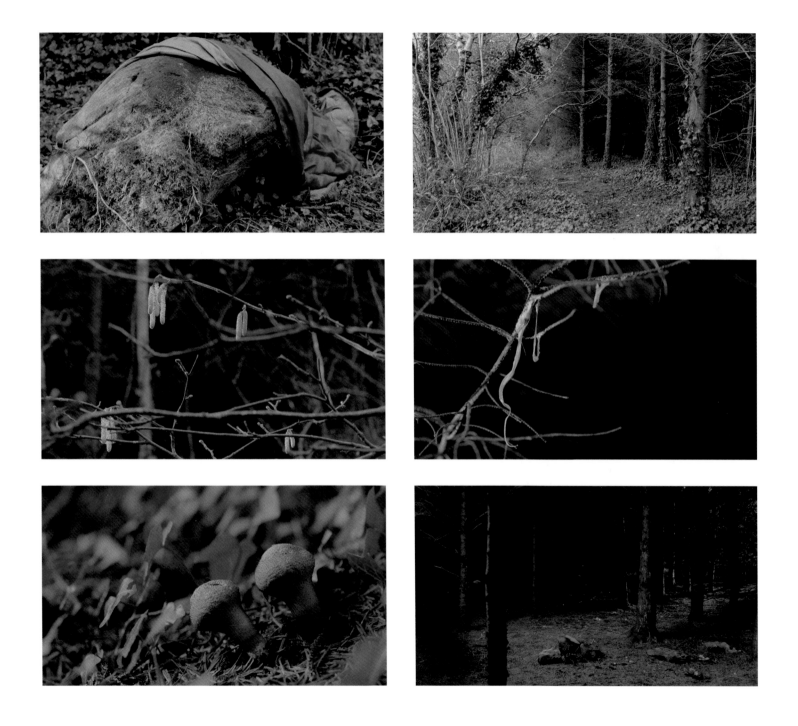

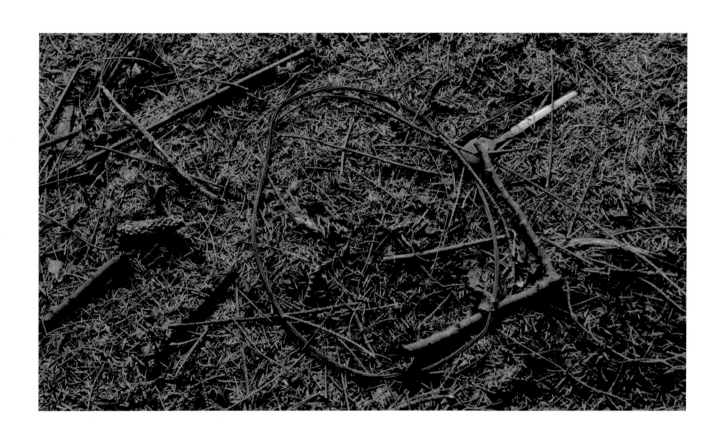

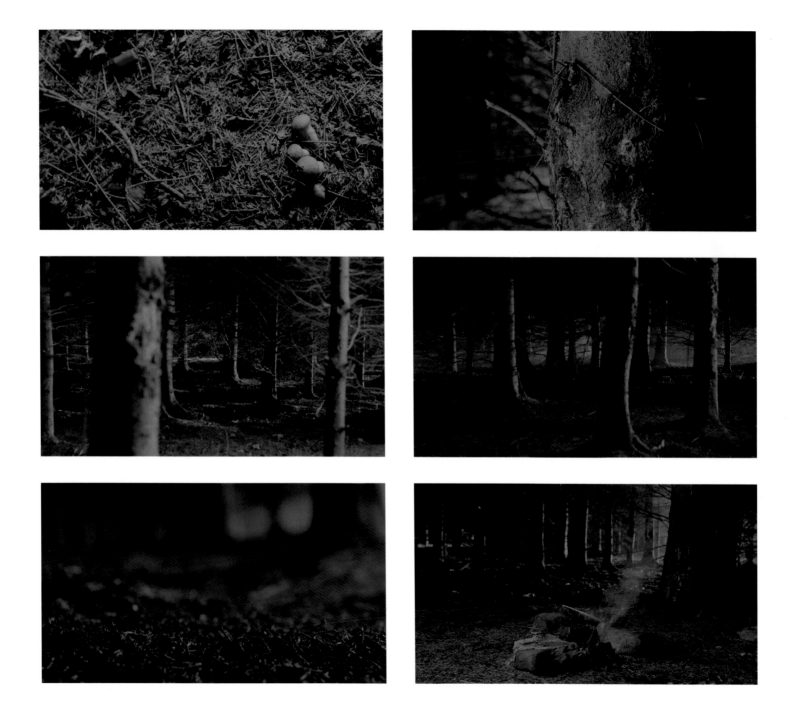

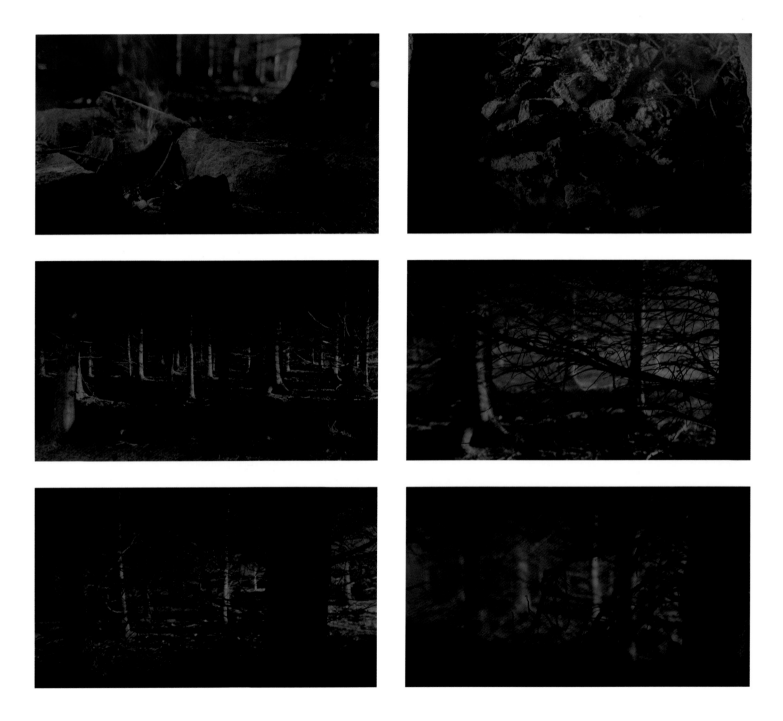

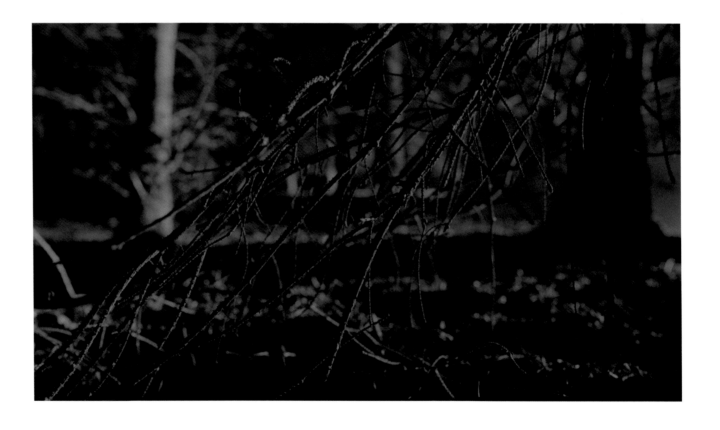

Three Potential Endings

2008

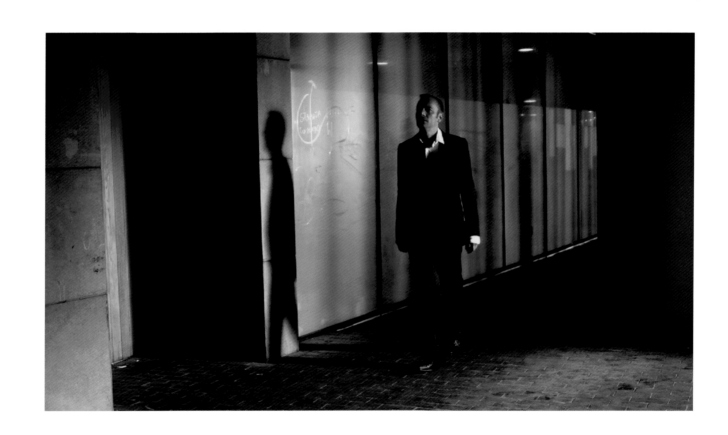

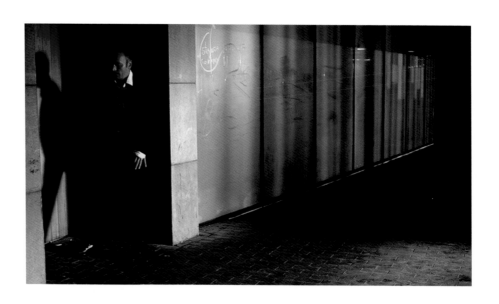

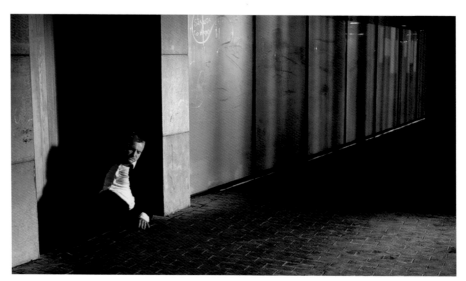

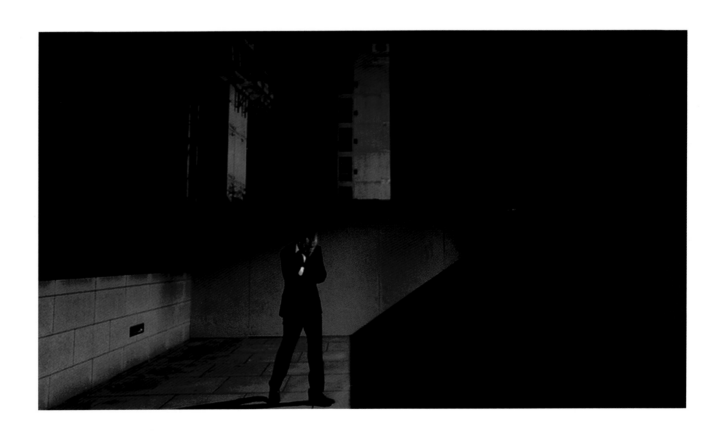

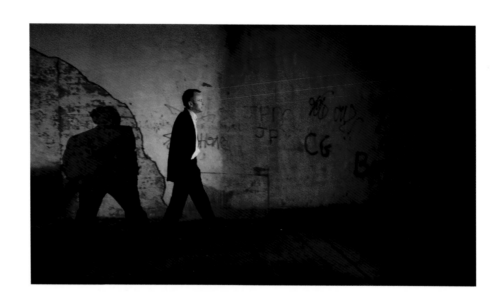

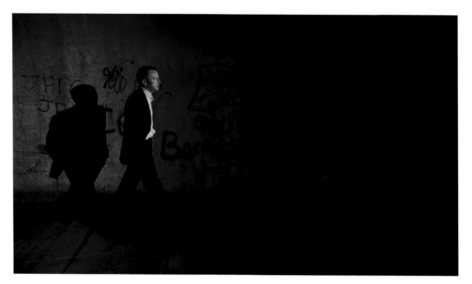

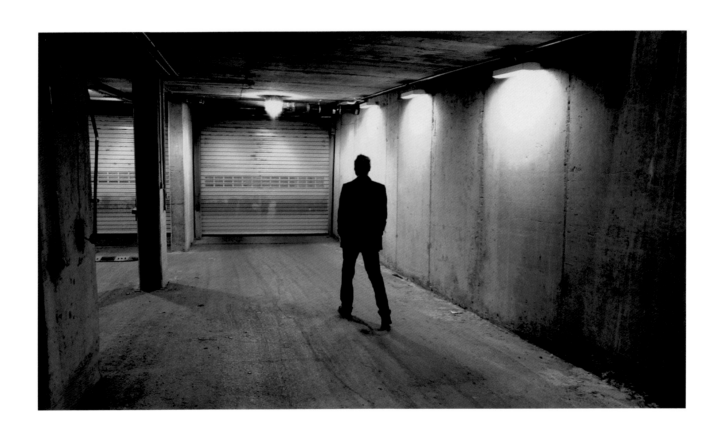

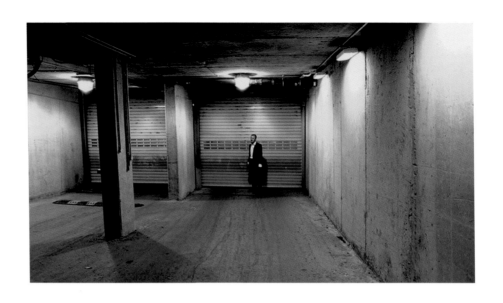

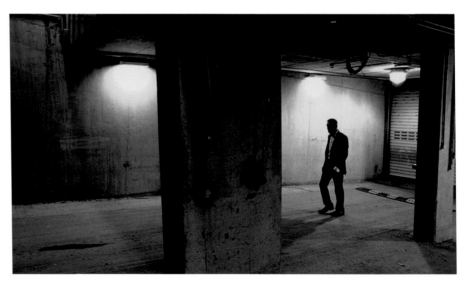

Non-Specific Threat

2004

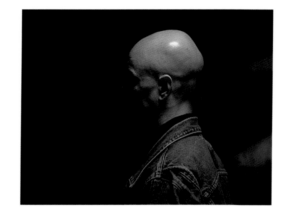

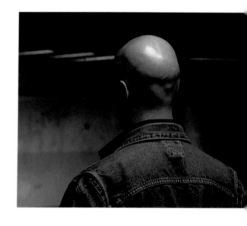

I will make your dreams come true.
You can be like me.
There will be no telephones.

I am any colour you want me to be.
I am any religion you want me to be.
I am the embodiment of everything
you despise.

There will be no water.
I am invisible.
I disappear in a crowd.
There will be no electricity.

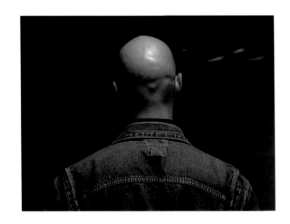 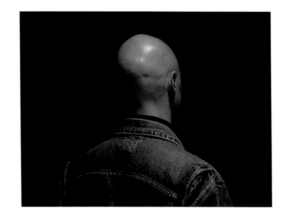 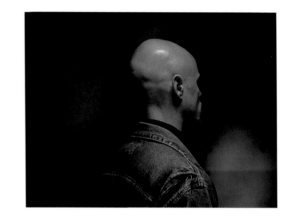

I am fictional.
I am the reflection of all your fears.
I am real.

There will be no television.
There will be no radio.
I live alongside you.
I have contaminated you.
I am part of your life.

There will be no computers.
I will be anything you want me to be.
You manipulate me.
You create me.

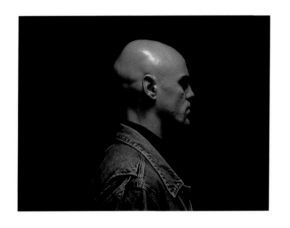 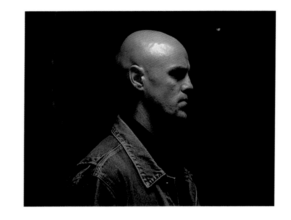 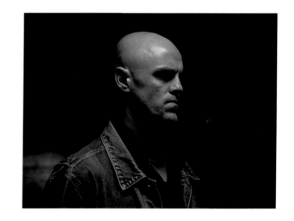

I am beyond reason.
I am unknowable.
There will be no books.
I am your invention.
You make me feel real.

There will be no flights.
You are my religion.
We control each other.
There will be no traffic.

I am everything that you desire.
I am forbidden.
I am inside you.
I am your annihilation.
Your death is my salvation.

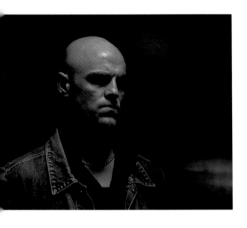

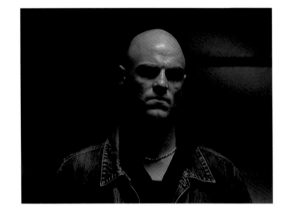

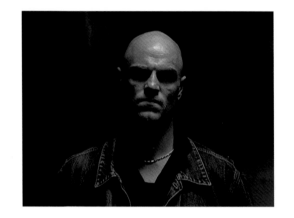

There will be no oil.
I am the face of evil.
I am self-contained.
There will be no music.

I am your victim.
You are my victim.
There will be no newspapers.
I share your fears.
I know your desires.

There will be no art.
I am part of your memories.
I remind you of someone
you know.
There will be no cinema.

Sometimes I imagine it's my turn

1998

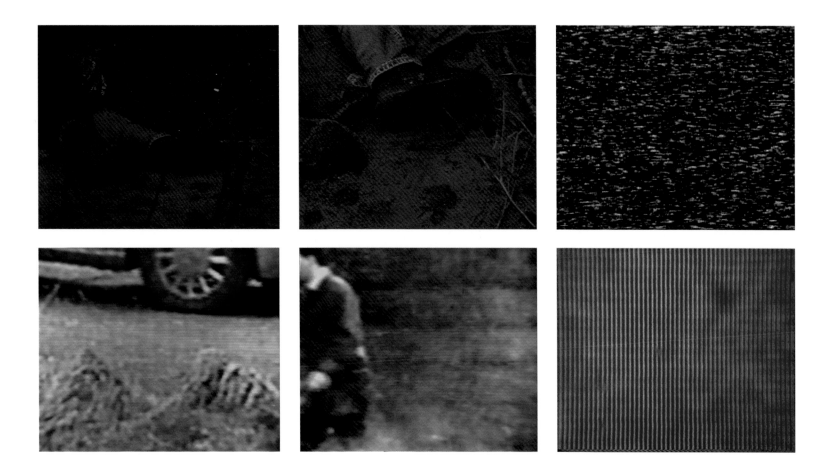

Blackspot

1997

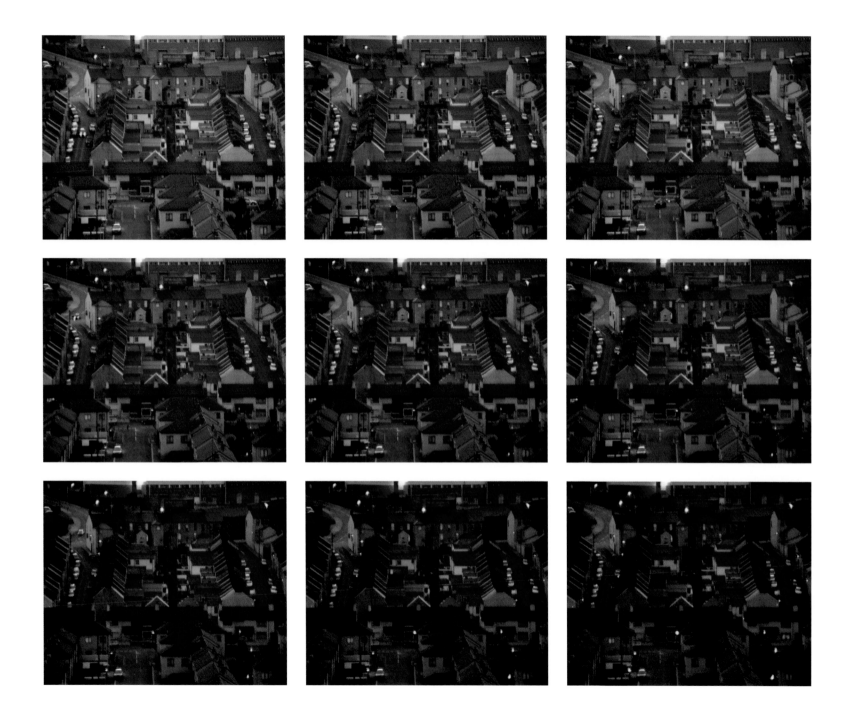

Photographs

The Blue Skies of Ulster
1986
Black and white photograph with text
46 × 152 cm
Unique
Private collection, Dublin

Mesh
1986
Black and white photograph with text
61 × 91 cm
Unique
Collection of The Contemporary Irish Art
Society on loan to The Irish Hospice Foundation

The Walls
1987
Black and white photograph with text
61 × 152.5 cm
Unique
Irish Museum of Modern Art, Dublin

Home
1987
Black and white photograph with text
61 × 152 cm
Unique
Private collection, Brussels

Protecting/Invading
1987
Black and white photographs with text
Diptych, each: 122 × 183 cm
Irish Museum of Modern Art, Dublin

Shifting Ground (The Walls, Derry)
1991
Black and white photograph with text
122 × 183 cm
Courtesy of the artist / Matt's Gallery, London

Native Disorders I
1991
C-type photograph with text
114 × 152 cm
Courtesy of the artist / Kerlin Gallery, Dublin

Native Disorders II
1991
C-type photograph with text
114 × 152 cm
Ursula Carlin and Geoff Kirk, Dublin

Native Disorders III
1991
C-type photograph with text
114 × 152 cm
Courtesy of the artist / Kerlin Gallery, Dublin

Disturbance
2011
C-type photograph
122 × 152 cm
Courtesy of the artist / Kerlin Gallery, Dublin

Dead Pool I
2011
C-type photograph
122 × 152 cm
Courtesy of the artist / Kerlin Gallery, Dublin

Dead Pool II
2011
C-type photograph
122 × 152 cm
Courtesy of the artist / Kerlin Gallery, Dublin

Rupture
2011
C-type photograph
122 × 152 cm
Courtesy of the artist / Kerlin Gallery, Dublin

Seepage
2011
C-type photograph
122 × 152 cm
Courtesy of the artist / Kerlin Gallery, Dublin

Videos

Ancient Ground
2011
Colour, sound, single screen installation
Duration: 8 minutes
Original format: 35 mm film transferred
to HDCAM
Courtesy of the artist
Screened 5 September 2011 – 15 January 2012

Segura
2010
Colour, sound, single screen installation
Duration: 10 minutes
Original format: HDCAM
Courtesy of the artist
Screened 25 October – 20 November 2011

Buried
2009
Colour, sound, single screen installation
Duration: 8 minutes
Original format: 35 mm film transferred
to HDCAM
Courtesy of the artist
Screened 5 September – 2 October 2011

Three Potential Endings
2008
Colour, sound, single screen installation
Duration: 11 minutes
Original format: HDCAM
Courtesy of the artist
Screened 4 – 23 October 2011

Non-Specific Threat
2004
Colour, sound, single screen installation
Duration: 7:46 minutes
Original format: DVCAM
Courtesy of the artist
Screened 22 November – 11 December 2011

Sometimes I imagine it's my turn
1998
Colour, sound, single screen installation
Duration: 3 minutes
Original format: Hi-8, BETACAM-SP
Irish Museum of Modern Art, Dublin
Screened 13 December 2011 – 1 January 2012

Blackspot
1997
Colour, sound, single screen installation
Duration: 30 minutes
Original format: Hi-8
Courtesy of the artist
Screened 3 – 15 January 2012

Willie Doherty
DISTURBANCE

Willie Doherty: DISTURBANCE
Dublin City Gallery The Hugh Lane
This exhibition, initiated by Dublin City Gallery The Hugh Lane,
is a collaboration with Dublin Contemporary 2011.
5 September 2011 to 15 January 2012

Curated by Barbara Dawson
Co-ordinated by Michael Dempsey, Logan Sisley and Padraic E. Moore

The Hugh Lane team for *Willie Doherty: DISTURBANCE*: Mary Broome,
Breda Byrne, Patrick Campbell, Dr. Margarita Cappock, Gerard Crotty,
Evelyn Curley, Anthony Donegan, Dorothy Doyle, Thomas Kavanagh,
Peadar Fitzgerald, Dolores Fogarty, Christopher Ford, Liz Forster,
Tim Haier, Sarah Healy, Veronica Heapes, Liam Kenny, Monika Keska,
Simon Lawlor, Mary Monaghan, Peadar Nolan, Niall O'Connor, Jessica
O'Donnell, Jurgita Savickaite, Joanna Shepard, and Daron Smyth.

Dublin City Gallery The Hugh Lane wishes to thank the individuals and
institutions that have so generously lent their works to this exhibition:
Kerlin Gallery, Dublin; The Irish Museum of Modern Art, Dublin;
Matt's Gallery, London; The Contemporary Irish Art Society and
The Irish Hospice Foundation, Dublin; Ursula Carlin and Geoff Kirk,
Dublin; and those lenders who wish to remain anonymous; and the
following individuals who in various ways have helped to bring this
exhibition and publication together: Oliver Dowling, David Fitzgerald,
Christina Kennedy, Felicia Tan, Sue McDiarmid, Holly Slingsby, Rebecca
Vodehnal, Niamh Byrne Rodgers, Colin Graham and Clare Harrington.

The artist would like to thank: John Kennedy, David Fitzgerald and
Darragh Hogan, Kerlin Gallery, Dublin; Robin Klassnik, Matt's Gallery,
London; Peter Kilchmann and Annemarie Reichen, Galerie Peter
Kilchmann, Zurich; Carolyn Alexander and Ted Bonin, Alexander and
Bonin, New York; Moises Perez de Albeniz, Galería Moisés Perez de
Albeniz, Pamplona; Sue MacDiarmid, Pearse Moore, Seamus McGarvey,
Conor Hammond, Noah Eli Davis, Brian Livingston, Davy Bates, Andy
Gardner, Gerry Tracey, Keith O Grady, John Coyle, Thomas Engelbert,
Yolanda Riquelme, Richard Dormer, Mary Murphy, Colin Stewart,
Damian Nolan, John O'Neill, John Martin, Justine Scoltock, Vinny
Cunningham and Billy Gallagher.